REMEMBERING
NORWOOD

REMEMBERING
NORWOOD

Win Everett's Tales of Tyot

WIN EVERETT

EDITED *by* HEATHER S. COLE
& EDWARD J. SWEENEY

Charleston · London

THE
History
PRESS

Published by The History Press
Charleston, SC 29403
www.historypress.net

Front cover: Norwood, Summer 1890. Oil painting by Edward J. Sweeney, 1972.
Back cover: Courtesy of the Norwood Historical Society.

First published 2008

Manufactured in the United States

ISBN 978.1.59629.568.1

Library of Congress Cataloging-in-Publication Data

Everett, Willard Winthrop, 1878-1947.
Remembering Norwood : Win Everett's tales from Tiot / Willard Winthrop Everett ;
edited by Heather S. Cole and Edward J. Sweeney.
p. cm.
ISBN 978-1-59629-568-1
1. Norwood (Mass.)--History--Anecdotes. 2. South Dedham (Mass.)--History--Anecdotes.
I. Cole, Heather S. II. Sweeney, Edward J. III. Title.
F74.N99E95 2008
974.4'7--dc22
 2008041954

This book is dedicated to the memory of the late Bettina Cottrell.

CONTENTS

CONTENTS

FOREWORD

In the 1930s, local history came into its own in the pages of community newspapers across America. Long the bailiwick of leisured gentlemen and commercial publishers who marketed ancestor worship and tales of self-made Anglo-Saxon men, local history had become dull and formulaic. Driven both by discernible pride in their own heritage and concern that ethnic diversity (the result of increased immigration) would dilute their shared foundational myth, most local historians had lost their relevance.

But in the 1930s, journalists seeking to attract and maintain readers turned to local anecdotes, semi-historical tales and local color to enlighten and amuse. Using old wives' tales, local gossip and family stories passed down from generation to generation, they sought to entertain more than educate, yet managed to turn history on its head. They often took things out of context, were sometimes careless with the facts, generalized too easily and stretched the truth to ensure a witty punch line, but they produced work that was far livelier than existing local history tomes and shed light on subjects and places long neglected. They made local history accessible and exciting. And, decades before academic historians began to focus on the experiences of immigrants, women, slaves and foot soldiers, these journalists were bringing the stories of ordinary people to their readers.

Win Everett was just such a journalist. He loved Norwood, and that affection is obvious in the selected "Tales of Tyot" presented in this volume. A natural-born storyteller, Everett brought to life the village of South Dedham (later Norwood) and its collection of distinctive characters and memorable events. His articles were extremely popular in town; people enjoyed reading them as much as he obviously enjoyed writing them. "History didn't simply

happen somewhere else," he seems to be telling his neighbors and friends. "It happened here."

These feature stories rescue and preserve an important part of Norwood's history that would have been lost. The selected writings reproduced in this book will enable a new generation to read, enjoy and retell Everett's "Tales of Tyot."

Patricia J. Fanning, PhD
Former President, Norwood Historical Society
August 2008

ACKNOWLEDGEMENTS

The editors would like to extend their appreciation to the descendants of Win Everett, particularly Win Cottrell, Stuart Cottrell and Kim Cottrell, for sharing family photographs and stories. Thank you to Joe Welch of Norwood's Department of Public Works and Kathy Bane, Jim Flaherty and Steve Lydon of the Norwood Fire Department for their assistance in tracking down early department photographs. Thank you to Bob Donahue for sharing his extensive local history collection. Thank you to the board of directors of the Norwood Historical Society, especially Patricia Fanning, for their support of this project and loan of most of the historic photographs that follow. And a special thanks to the staff of the Morrill Memorial Library for aiding in the start of this project. Thank you to our typists, Margo Washburn and Barbara O'Connor, and our proofreader, Katherine Russell. Appreciation, too, to our editor at The History Press, Saunders Robinson. And, of course, thank you to our families for their support and patience with our local history endeavors.

Introduction

THE TALETELLER
OF TYOT

On Sunday, March 17, 1878, Willard Winthrop Everett was born in Golden, Colorado. He came to Norwood with his parents in 1885. On Sunday, November 9, 1947, one of Norwood's most prolific journalists and local historians, Win Everett, age sixty-nine, passed away quietly at the Norwood Hospital. His legacy was the countless words that he assembled during his career and packaged like no other of his fellow town chroniclers. Best known for his "Tales of Tyot" local history columns, his was a new and different approach to recording the growth of the town and its people.

"Win," as he was affectionately called by all those who knew—or knew of—him, was an archetypical journalist of the 1930s. He covered historic Norwood events and their participants, as well as the "just plain folks" who populated the town. He made local history real in every one of the more than one hundred "Tales of Tyot" columns he produced for the local newspaper, the *Norwood Daily Messenger*, between 1931 and 1938.

In many regards, Win was a twentieth-century Renaissance man. A 1901 graduate of Amherst College with a bachelor of science degree in biology, his admitted love was writing. That surfaced when, after a short stint at the Rochester (New York) Natural History Museum, he embarked on what would be a long career in the world of journalism. He started as a reporter in Springfield, Massachusetts, and for the *New York Sun*. He worked as an advertising copywriter for a national trade journal in New York and Boston and returned to his family home in Norwood. Win began writing for the *Norwood Daily Messenger* and became editor in 1937.

In September 1911, Win married Florence Swan of New York City. The couple raised two daughters, Bettina and Carol. Bettina (Mrs. Stanley

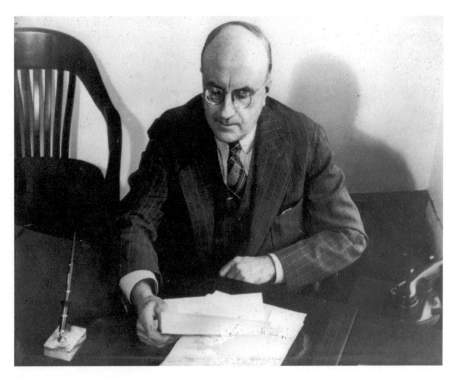

The Teller of Tales, Win Everett, at work. *Photograph courtesy of the Norwood Historical Society.*

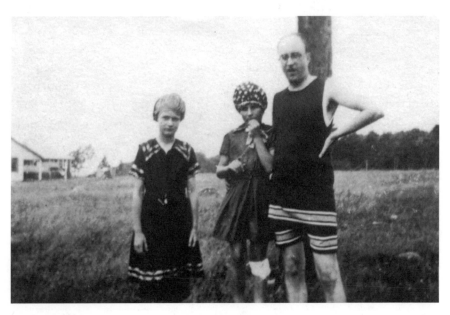

Proud father Win Everett with his daughters, Bettina and Carol, in the mid-1930s. *Photograph courtesy of the Cottrell family.*

Cottrell) was an active member of the Norwood Historical Society for many years. Sadly, she passed away in July 2008, just as this collection of her father's columns was being prepared for publication.

A member of one of Norwood's oldest and most prominent families, Win was a descendant of Richard Everett, who was granted land in colonial Dedham in the early seventeenth century by the king of England. He was related to Willard Everett, founder of the mid-nineteenth-century, nationally recognized Everett Furniture Factory. His mother was a member of the Hoyle family—socially prominent in Norwood's early development.

Win took great interest in family and local history. Over the years, he became Norwood's unofficial historian. He amassed a large collection of photos and documents relating to the history of the town. He served on the board of trustees of Norwood's Morrill Memorial Library from 1924 to 1944. He also was a charter member of the Norwood Historical Society. In 1934, Win put his journalistic magnifying glass on Norwood when he conducted a historical survey of the town for the Depression-era Federal Emergency Relief Administration. That year-long survey produced a detailed public document

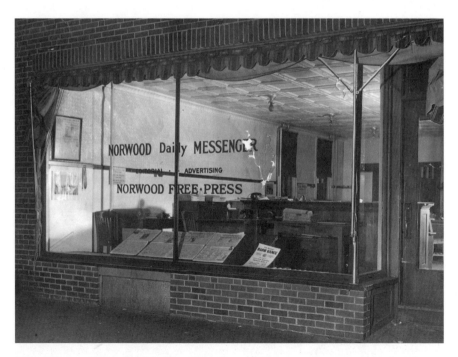

The 1930s storefront editorial office of the *Norwood Messenger*, where reporter, columnist and features editor Win Everett wrote more than one hundred "Tales of Tyot." *Photograph courtesy of the Norwood Historical Society.*

and sparked a generation of the very popular "Tales of Tyot" for the *Norwood Daily Messenger*. In 1935, Win presented his local history columns in bound volumes to Norwood's Morrill Memorial Library, the Norwood Historical Society and the Commonwealth of Massachusetts, expressed in his words, "with the hope that it may be of some small assistance to future historians."

The "Taleteller of Tyot," beyond his standing as a reputable popular journalist, in the words of his minister, was "highly respected as quiet and unassuming, a gracious, artistic soul in the practical sense of the word." The November 10, 1947 obituary of Win Everett, the beloved newspaperman and historian of Norwood, was replete with outstanding tributes from people in all walks of Norwood life. Harry P. Harwich, the publisher of the *Norwood Daily Messenger*, described Win as "a sincere, humble, and gifted human" for whom "unfailing good cheer, steady wisdom, and rare charity went hand in hand with brilliant literary talent." A fellow newspaperman said of Win, "He will be remembered as a fine, scrupulously honest newspaperman of the old school, homespun in his writings, a cheerful companion and a man of strong convictions. He was a newspaperman from the time of his first writing until he died last night, and a good one every day of his working life."

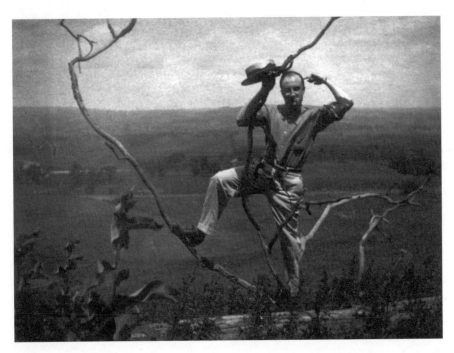

The "fun side" of Win Everett poses for a casual photograph. *Photograph courtesy of the Cottrell family.*

"Tales Of Tyot"

—:—

"Tyot" (or "Tiot") Was the Indian Name for the Territory Which Became Norwood, Massachusetts. It Meant "Place-Surrounded-by-Waters"

—:—

The following sketches, originally printed in the Norwood Messenger, embody much of the information gathered in an Emergency Relief Administration project conducted in and by the town of Norwood, Mass. from August 1934 to August 1935. The project was an Historical Survey of the town's history. For the reasons given below, it was thought wise to use the facts thus gained in newspaper articles such as the following, rather than to present them in formal and more statistical reports:

First; Because Norwood has no printed and published volumn of its history, covering all phases of its history. Whatever has been written about the town is widely scattered in old newspapers, official reports, pamphlets and other sources. While much of its history has never been printed but is in the minds and memories of elderly people.

It was therefore first imperative for such a research as the ERA officials had in mind to begin to collect and collate in some general way whatever information could be secured. The first steps must be by a sort of "trial and error" plan, since much of the data was almost forgotten. Having secured and authenticated it as much as possible, it was thought it would be easier to extend it at some later date, perhaps, into a more concise and formal history of the town of Norwood.

The matter contained in this book, therefore, can only be considered as "source material" and not as a complete history. There are some unavoidable errors, which have been corrected in certain cases. On the whole, the author feels that future historians can use this book for source purposes with considerable confidence. Dates, of course, should be carefully checked. Corrections made in ink are O. K.

The second reason for these newspaper sketches was to awaken the latent interest of the townspeople in this project, and enlist their cooperation in getting facts and needed material. Without such public cooperation such a project was foredoomed to failure under the conditions existing in Norwood. The undersigned Connoisseur of Historical Data, who conducted the research, is glad to state that these little stories have admirably served the purpose for which they were designed. The Norwood public, as well as former citizens all over the country, were aroused to deep interest. They have brought the undersigned more help, information and friendly enthusiasm than he can well express in this space. Old friendships have been renewed and new ones made. His gratitude is deep, for he realizes that this public interest has been largely responsible for whatever success this project has attained.

The undersigned therefore offers this collection of data to the Commonwealth of Massachusetts with the hope that it may be of some small assistance to future historians. He also offers it to the town of Norwood for the same purpose, and has caused two duplicate copies of this book to be made. One will be cataloged in the Morrill Memorial Library of Norwood for public use. The other will be placed in the library of the

Willard Winthrop Everett.

Norwood Historical Society.
Project Number; X20223F2—U2
Identification Number; 397
Dated at Norwood, Massachusetts.
August 28, 1935

Connoisseur of Historical Data

Bound copies of "Tales of Tyot" were presented by Win Everett to the Norwood Historical Society and Norwood's Morrill Memorial Library with this introduction: "for assistance to future historians." *Courtesy of the Norwood Historical Society.*

A NOTE FROM
THE EDITORS

All of the following stories were written by historian/journalist Win Everett and originally published in his "Tales of Tyot" column in Norwood's now-defunct local newspaper, the *Norwood Daily Messenger*, between 1931 and 1938. To reproduce all of Everett's more than one hundred "Tales of Tyot" in their entirety would require a book far in excess of the contents of this volume. Instead, we selected columns that we believe best represent the breadth and depth of Everett's local history writings and minimally edited them for continuity and space. We have left Everett's colorful language and, in some cases, unorthodox spelling intact, and hope that the reader will appreciate the stories in their early twentieth-century context.

Readers should note that, in some specific situations, Win took journalistic liberties to expand the "Tale." Also, some of the places mentioned in the "Tales" that follow no longer exist, except in the memories of some still-living "old-timers" and in the archives of the Norwood Historical Society. Readers wishing to learn more about Norwood's rich history or read more of Win Everett's writings are welcome to contact the Norwood Historical Society or Norwood's Morrill Memorial Library.

Heather S. Cole and Edward J. Sweeney, Editors

BIRTH OF A COMMUNITY

*W*in Everett, chronicler, begins the Tyot (also spelled "Tiot") saga before the
founding of its mother town, Dedham, in 1630. Set against the backdrop of
a vast wilderness of forests, swamps, grassy meadows and Indian trails, in this opening
section, Win paints a picture of a first settlement along the pristine waters of the swift-
flowing Neponset River. In this all-too-brief selection of representative "Tales of Tyot,"
Win describes the effort of a handful of pioneer farmers gradually pushing the frontier
physically, socially and spiritually to create an embryonic society that eventually became the
robust community called Norwood.

WHY IT WAS CALLED "TIOT"

Originally published on December 31, 1934

Unlike most individuals, Norwood has been baptized three times. First by
the Neponsets, which were the local tribe of the greater Massachusetts
Indian tribe. The Neponsets called Norwood "Tiot." They called the
mother town of Dedham "Tist." Secondly, by King George the Second's
Great and General Court of the Massachusetts Bay Colony, which dubbed
it, in 1734, the "Second or South Precinct of Dedham," familiarly known as
"South Dedham." Thirdly, by Tyler Thayer, last of the "Master Builders,"
that ancient New England craft that built staunchly, and sometimes
beautifully, without architects' plans. Mr. Thayer sold South Dedham the
name "Norwood" when the town was incorporated in 1872.

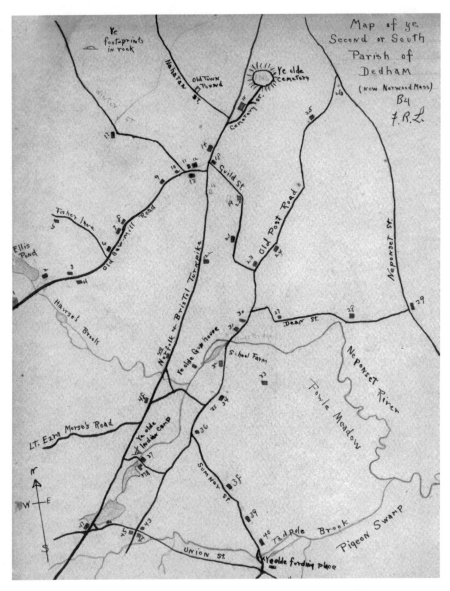

This early map of South Dedham shows some of the streams and the Neponset River that earned the area the nickname Tiot, or "an enclosure of waters." *Map courtesy of the Norwood Historical Society.*

Birth of a Community

We have to go to the dictionary of the wide-flung Algonquin tribe, which included the Massachusetts, to find the meaning of "Tiot." You will see that all the Algonquin words hereabouts are inspired by the location of the thing they designate, by some picturesque quality or imaginative significance. The Indians had thirty terminal syllables meaning "land" or "place." But the Massachusetts tribe cut these down to five—"at, et, it, ot and ut." "Ot" came from the root "akki, ahki, auke or ohki." In English, it means "land or place."

The early English colonists were notoriously phonetic in their spelling. So they shortened the Algonquin word "Teigh" to "Ti." The root meaning of "teigh" is "river or waters." It was Mr. and Mrs. Ernest J. Baker of Westwood who made the discovery, in a book of Indian words, that the word "tiok" means "inclosure" [*sic*]. So, putting it all together, we find that Tiot means "a place or inclosure of waters." Mr. F.P. Orchard, curator of the Peabody Museum, Cambridge, tells the writer that the modern school would spell it "Tieott."

But, you will naturally say, Norwood has no "waters." There isn't a natural pond of any consequence within its borders, and only one small river. But if you will look at a map of Norwood while imagining what this country looked like when it was all virgin forests, with our present tame little brooks raging, foaming torrents, you will suddenly realize how truly the Indian mind pictured Norwood in its descriptive word "Tiot." The accent, by the way, is on the last syllable, if you don't happen to know.

Norwood is indeed an "inclosure." It is bounded on all sides by water—"a place of waters"—all running to the Neponset. Away over in "the Bogs" of Foxboro, the Neponset starts to flow eastward in a lazy, zigzag journey. It is joined by Mine Brook of Dover, which enters Norwood on the southwest. Then, Traphole Brook from Walpole, Maskwoncut Brook and the whole of the East Branch of the Neponset River, which drains Massapoag Lake in Sharon, the Stoughton ponds and brooks and the Canton reservoir all enter the Neponset on our northern border. Purgatory Brook, winding down eastward from Westwood, circles to our north and east before it meets the Neponset. While on the west, you will note that Bubbling Brook (a lovely colonial name that has been killed by the homely, meaningless substitute of "Germany") with Mill or Foundry Brook are watery barriers. And do not overlook Buckmaster (or Flax) Pond in Westwood, which formed an important unit in the redskin's picture of old Tiot.

If you think that this charming Indian name of the Norwood territory was a mere fanciful title that faded away when the white men came up the Charles to Dedham in 1636, you are quite wrong. It was so well established

among the colonists that you will find it in some of our earliest title deeds. That Pleasant Street post road, "the old country road" from East Street, Dedham, through Islington, Norwood and East Walpole, was long called "Tiot Road." Do you know that this was the first great inland road ever cut through the wilderness of the United States?

Long after "Tiot" officially became "South Dedham" in 1734, people continued to call it "Tiot." Many people still living in Dedham, Canton and Walpole can easily remember when their fathers and grandfathers used to casually and naturally say, "I've got to go over to Tiot and see a man about buying a dog."

Now we come to that pregnant year of 1872 in Norwood's history. Here was our embryo Norwood with two perfectly swell Indian names to pick from, both with a noble pedigree, both full of color and interest, both unique—Tiot and Neponset. And they named the baby Norwood! Ah, well! It was the time when folks were beginning to put the beautiful old mahogany four-posters and the exquisite maple and mahogany bureaus in the attic and replace them with dreary black walnut, decorated with genuine hand-carved thingamabobs—the What-Not Age was here. Norwood came in with the

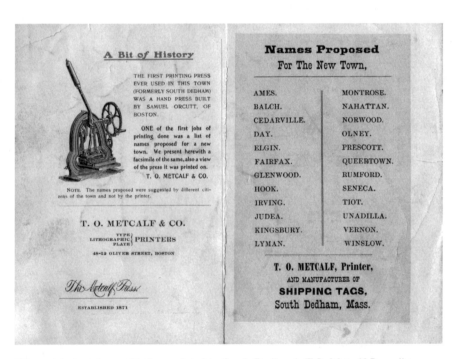

What might have been: this flyer, printed by South Dedham's T.O. Metcalf Press, lists some of the names considered for Norwood. *Courtesy of the Norwood Historical Society.*

Tyler Thayer, major Norwood builder, suggested "Norwood" for Dedham's south precinct when the town was incorporated in 1872. Later, he served as a Norwood selectman and Massachusetts legislator. *Photograph courtesy of the Norwood Historical Society.*

meaningless cast-iron décor on the lawns and atrocious little iron darkie hitching posts, the mansard roof, the wax fruit on the parlor table and the massive watch chain across the abdomen.

Yet they took this christening of our town pretty seriously. Everyone was invited to send in their pet name to the selectmen for town-meeting consideration. Here are the candidates, according to a list by Mrs. Marcia Winslow in an address she made in 1903: Ames, Balch, Cedarville, Day, Elgin, Fairfax, Glenwood, Hook, Irving, Judea, Kingsbury, Lyman, Montrose, Nahatan, Norwood, Olney, Prescott, Queertown, Rumford, Seneca, Tiot, Unadilla, Vernon and Winslow.

Tyler Thayer was the propagandist for "Norwood." He said he had looked over the index of Johnson's atlas of the United States and found there was only one Norwood in the country. It was in Stanley County, North Carolina. (There is now a Norwood in practically every state in the Union.) Mr. Thayer was pleased with the name, said it looked well in print (no *i*'s to dot or *t*'s to cross), had a pretty sound and he was strong for it. So, since he had built about half the homes and factories in town, they allowed him to erect the town's name. This, despite the fact that the name did not have a blessed thing to do with any geographic, commercial or historical feature of the town.

There's another pretty legend, sponsored by Mr. F.O. Winslow, that they named Norwood after Henry Ward Beecher's novel *Norwood—or Village Life in New England*. This novel was a dud, being little read at the time and completely forgotten now.

After they had broken a bottle of Bubbling Brook over the prow of Norwood and launched her, they discovered a Norwood near Dedham, England—which made everything just dandy.

Four Periods of Growth in the History of Norwood

Originally published on March 10, 1933

Norwood's historical graph is accentuated by four peaks, each bigger than the last, and for the moment we are on the declining side of the fourth one.

Let us go back to 1630, the year in which Dedham was founded. Norwood at that time was just a vast wilderness of forests, swamps, meadows, wolves and Indians. It was a long time before a trail was broken through to the south and the land discovered to be especially valuable, principally the Canton Meadows, where the grass provided excellent fodder for cattle.

Birth of a Community

All this area was gobbled up by a comparatively few people. They knew a good thing when they saw it, and they kept South Parish to themselves. For years, Norwood was a closed community of crabbed, selfish, shrewd, inhospitable farmers who didn't like strangers and used every strategy to hasten their departure.

This pastoral regime continued until the latter part of the eighteenth century. By then, a small tannery had been established near the present location of the Winslow plant, the first store was set up near St. Catherine's Church, the second on the corner of Dean and Washington Streets and a blacksmith shop where the Congregational parsonage now stands. That was the crest of Norwood's first wave of prosperity. Business was insignificant alongside of farming.

Let me say here that Norwood's development has been duplicated remarkably by the development of the United States. In fact, you might say the United States gradually crawled in and absorbed Norwood.

Perhaps we would still be like the hundreds of country towns you see in New England if it weren't for the railroads. They broke the ice, brought the first flicker of nationalism, gave us our first glimpse of the outside world.

There's an interesting story told about the advent of the railroad. I can't vouch for its truth, but it makes a good story. I am told that when the first railroad line was laid out, the surveyors projected it across East Walpole, and when construction began, the workers used water from the Bird millpond. The original Mr. Bird had the water rights and, like the smart Yankee that he was, took advantage of his opportunity to make the railroad pay the limit for water. Naturally, the railroad didn't like it and, in a fit of peevishness, swung the line through Walpole, left the Bird mill high and dry and made Bird haul his products several miles to the freight station.

There's another side to the story and a moral. My Grandfather Everett, a farmer who was handy with tools, took up the making of furniture as a sideline. His first shop was later used by old George Morrill for the original ink mill. Later, my grandfather moved to Hoyle and Washington Streets and, finally, a large factory was built on the football field of the Civic.

When my Uncle George Everett was running this plant, it was the chief industry in the town, employing as many as 280 people. Several other similar lines came in here, and at that time Norwood had all the aspects of becoming a Gardner or Grand Rapids.

George Everett was likewise hardboiled, cagey and thrifty. He heard that the railroad was planning to build a repair shop in Walpole. But Walpole landowners were all ready to soak the railroad.

George, realizing how much an added industry would help Norwood, went to the railroad and offered to give them, free, his cow pasture across the tracks from the factory. Naturally, the railroad took it and added a third industry to the furniture factory and tanneries. They brought a fine class of people to the town and did much to aid Norwood until about 1900, when the shops were removed to Readville.

But here is the point: shortly after George Everett carried out his generous deed, the furniture plant burned down with such a loss that it could not reopen. On the other hand, Bird, who tried to beat the railroad, headed a flourishing business, which has become one of the leading firms in New England. It pays to be shrewd.

The third peak arrived with the advent of the printing plants here through the efforts of the chamber of commerce, which instigated the establishment of the Norwood Press. Later, Mr. Plimpton erected his own plant on Lenox Street. The net result was to make Norwood, at that time, a community of the most intelligent and highly skilled labor in the United States.

I well remember the party that attended the opening of the Norwood Press, along about 1896, the biggest and swankiest social gathering the town had ever had. Everybody wore swallowtails and evening gowns. The entire

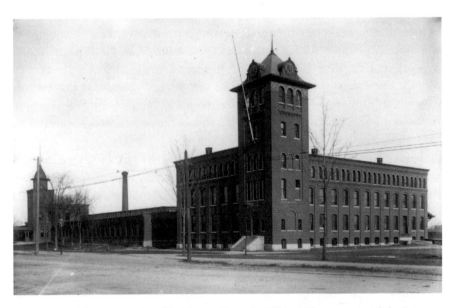

The Norwood Press opened on Washington Street in 1894 and became one of the largest industries in early twentieth-century Norwood. *Photograph courtesy of the Norwood Historical Society.*

place was thrown open, and dancing was enjoyed until four o'clock in the morning.

With these two plants in operation, the United States came in and settled in Norwood. Retail business grew and stores increased on Washington Street.

The year 1900 is the most important date in this town's history, in my opinion, for at that point George F. Willett entered as the most important influence in our lives.

Mr. Willett was put on a committee to investigate our tax problem. As I recall it, Mr. Willett wasn't then particularly interested in civic projects. He was appointed to the committee and became a leader in Norwood's development because of his work with this group.

In 1908, our taxes were very high due to an unequal distribution of the assessments. Before Mr. Willett's committee got through, they had brought the tax rate from around twenty-eight dollars down to eight dollars.

Now, no matter what you may think of George Willett—whether you agree or disagree with what he has done—I urge you to be charitable. George Willett was the symbol of a great movement that began then and is just ended now.

With that movement, the United States swept into Norwood. We learned about banks and Wall Street and quick ways of making money. We had new business efficiency, the force of big money, survey plans, programs for betterment.

Our town was literally torn to pieces like a watch and put together by a new group of people. Whether all this was right or wrong is not for me to say. Each one has his own opinion about that.

It did bring us poverty, the worst Norwood had ever seen, and the absentee landlord. Armour bought Winslow Bros. & Smith; the American Brake Shoe Co. bought the old car shops; the ink mill was recently acquired by a New York firm; and our stores are gradually becoming absorbed by the chains. Everyone is an outsider, a stranger to Norwood, without any interest in the town except to make money out of it. It's something for you to think about

This is the situation at the fourth peak—the point we like to think we are sitting on [in 1933], but ain't.

THE ARCHITECTURE OF TIOT

Originally published on August 18, 1936, as part of "5 Frontiers of Norwood"

In the beginning, about 1700, and probably right through the eighteenth century, the plain, simple, unadorned Puritan farmhouse was the rule in the South Parish. We had no plutocrats, retired sea captains or wealthy

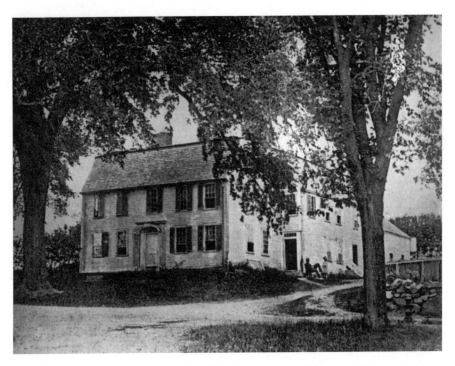

An early center of South Dedham village life, the parsonage of Reverend Thomas Balch was built in 1736 on Walpole Street. *Photograph courtesy of the Norwood Historical Society.*

professional men, such as many other New England towns have boasted. Dedham and Portsmouth, for instance. We were farmers, and tight, penny-pinching farmers at that. Spare money went into more land and not larger or more pretentious houses.

In all this period, there was only one truly handsome residence in Norwood—the Balch Parsonage. And that, in truth, was merely a simple gambrel-roofed building, with a long wing on the rear with a beautiful, sloping roof. But its commanding position at the head of Guild Street, on the edge of Beacon Hill, together with the magnificent pair of elms that drooped lovingly over it, while others shaded it on both sides, made the Balch Parsonage a place to remember—as something once seen in a dream. The rest of the houses were just plain gable-roofed structures, or "saltbox roof" farms, with a long, sloping roof in the rear that was built thus originally, or added on when the babies began to come.

The Ebenezer Dean House, supposed to have been built about 1720 or '30, still standing halfway up Dean Street on the north side, is undoubtedly the oldest house in Norwood still on its original foundation [in 1936]. It is a good example of the better-class house of this period.

Norwood's oldest home, the saltbox-style Ebenezer Dean House, was saved by a local preservationist and moved to its 2008 location on Bond Street. *Photograph courtesy of the Norwood Historical Society.*

So the years of the 1700s drifted by. New people gradually filtered in. A little more prosperity and better taste became evident. In the early part of the nineteenth century, a different type of house appeared.

Of this newer and larger type, precious few are still standing. One is the Dean Chickering House on Walpole Street at the head of Hoyle Street. From the angle of authentic architectural worth and beauty, it is regarded as the most beautiful house in town. Had the Balch Parsonage been preserved, it would have topped it in every way and would have been one of the most outstanding colonial mansions in New England—priceless from both a money and historical viewpoint.

The Fairbanks House at 287 Prospect Street is in this period, but it is so modernized that it does not count. The old Capen House on Pleasant Street near the Callahan School is perhaps the most authentic example of the early nineteenth-century building we have in its original condition. It stands, according to a Fred Day record, on or near the site of the original Samuel Thorp House, which was one of the first built in the South Parish. Down in the Hawes Neighborhood on Sumner and Union Streets, you will find a few other early nineteenth-century homes. But they, too, have been largely

The Dean Chickering House was built in the early 1800s and is still standing at the intersection of Walpole and Hoyle Streets in 2008. *Photograph courtesy of the Norwood Historical Society.*

changed and their original character destroyed. In a word, the careless and mercenary rush of ever-coming waves of strangers, all eager to build up "a bigger and better" Norwood, have stripped our town of almost every vestige of eighteenth- and nineteenth-century flavor—leaving us a legacy of unbeautiful, commonplace, early-Victorian architecture, plus a rather pathetic codicil of jigsaw gingerbread, English half-stucco manor houses, baronial castles, chateaux and other imported vintages that are neither in the best of taste nor American.

The coming of the railroad and factories began to pour real money into Norwood for the first time in its history. The houses reflect this in the Hook section. "Dublin" and "Cork City" are composed of neat little cottage-type homes, built carefully and with pride by men who owned them. All of them are better built and more comfortable homes than the early ones of the pioneers.

Then, as the Hook grew, the merchants and professional men, with those who were making good wages in the factories, built up the Hill and North Washington Street with a finer type of house than any we had previously possessed. None of them are beautiful by modern standards. The ugly mansard roof was popular. There were many angles and homely lines and much unnecessary decoration. Yet, in the main they were big, roomy homes and said to the admiring world, "My owner has money!" The best-looking

quartette of these were the Bigelow, Charles Smith, Baker and Joseph Day Houses between Cottage and Day Streets on Washington. They were pure white with green blinds and set high on sharply banked lawns. Under the thick shade of the Washington Street maple trees, they gave the Hook an atmosphere of solid wealth and respectability. They offset its grimy and ugly little wooden store buildings.

Until the coming of the "press works," as they were quaintly called in my boyhood, Norwood was a town of 100 percent single-family houses. There were no apartment houses, no duplex or triplex houses and no tenements. That old, agricultural idea hung on. It wasn't quite decent to live in the same house with anyone else. The only thing resembling a tenement that I can remember in the 1890s was the "German Block" on Walpole Street near the tannery. This was a ramshackle row of mill houses all joined together. But the tenants all lived in their own homes, just the same!

The coming of the book-manufacturing business, with its many city folks used to metropolitan convenience, shattered this old Yankee situation. Not long after they settled here, the Talbot Block went up at the corner of

The 1855 home of Joseph Day was relocated from Washington Street onto Day Street in the 1910s to make way for the widening of Norwood's main street. *Photograph courtesy of the Norwood Historical Society.*

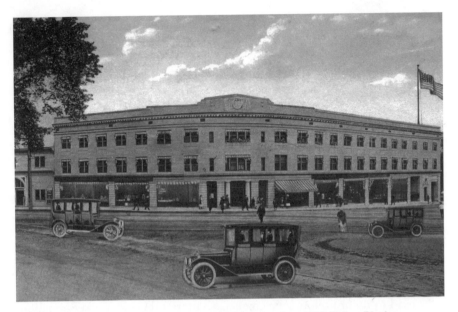

One of Norwood's first multiuse business buildings, the circa 1912 Talbot Block wraps around the corner of Washington Street onto Guild Street. *Courtesy of the Norwood Historical Society.*

Washington and Guild Streets. This, I am told, was Norwood's first apartment house. It was built by the grandsons of that sturdy Hook tycoon George B. Talbot, these pioneers in a new field being Judge Clifford B. Sanborn and his brother, the late Harry Sanborn. Two-, three- and four-family houses in various parts of the town began to appear, with other apartment houses being erected later.

About this time, a local and self-taught architect, Herbert Rhoades, broke away from the rather stiff, inconvenient and old-fashioned traditions of local architecture and began to build, on the J. Edward Everett property of his grandfather, the first of the good-looking, modern and well-arranged small dwelling houses. We understand that after Mr. Rhoades went to Portland, Maine, he became the architect of the great Eastland Hotel there, as well as a large church directly opposite it. This Norwood boy is recognized as one of Portland's leading architects.

Birth of a Community

KINGSBRIDGE ECLIPSE IN TYOT, WHICH TERRIFIED INDIAN FIGHTERS

Originally published on March 3, 1936

It has been generally believed that Norwood had no picturesque stories of early colonial Indian fighting. But we have! And it is one of the most colorful tales in the saga of King Philip's War!

I wrote a yarn entitled "The First Massachusetts Bonus Fight." It related how, after King Philip's War had been raging, on December 9, 1675, seven Massachusetts companies, under the command of Major Samuel Appleton of Ipswich, mustered on Dedham Plain and marched to South Kingston, Rhode Island, where they eventually slaughtered five hundred of Philip's braves and burned a thousand Indian women and children in their five hundred teepees with their stockade fort. Before they left Dedham Plain, the colonists had been promised a bonus of land, in addition to their pay, as a special reward "if they played the man, and drove the Narragansetts out of their fort." They did play the man, if you consider burning a thousand innocent women and kids to death such a play. But a previous expedition, in June 1675, which started after King Philip's War began, played the coward with a yellow streak a mile wide. And they did it in Norwood. That's the story.

It's another story of the old Roebuck Post Road, which we are always bound to wander along when we visit Norwood of 1675. It was the Country Road, now Pleasant Street. This rude path, in spite of its humble character as compared with modern roads, was, at the time of King Philip's War, the main way from Boston to the Wampanoag country (present Wrentham and Attleboro) and Rhode Island. "It was over the Country Road that the coming and going of troops, the stealthy passage of wandering bands of hostile warriors, the clash of actual conflict and the war-whoops of the braves were to disturb the primal quietude of the succeeding months," wrote Willard DeLue, local area historian in his *Story of Walpole*.

On June 24, 1675, news reached Boston that the bodies of two men had been found scalped in the road near Swansea. It was the unmistakable sign. King Philip had made his throw. The struggle now known as King Philip's War was on.

That same day, the General Court in Boston ordered "100 able souldjers forthwith impressed out of the severall Towns," and this company "mounted as dragoons" marched out of Boston and down the old Country Road two days later, with another troop of horses.

35

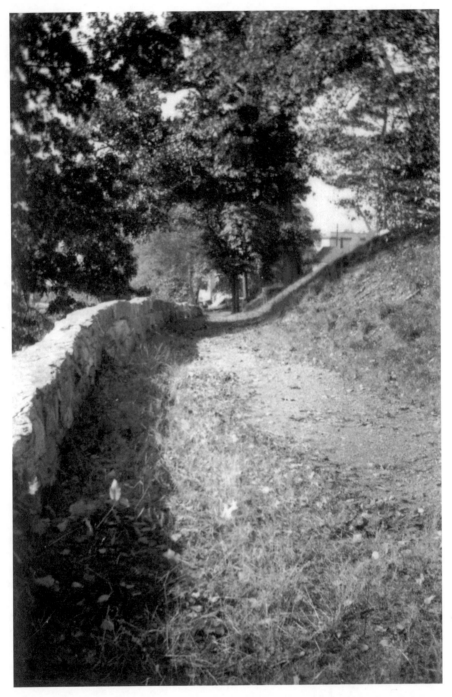

Road to the future? A circa 1944 snapshot of a piece of the Old County Road near Norwood's old village burying ground. *Photograph courtesy of the Norwood Historical Society.*

Birth of a Community

"In the afternoon of June 26, 1675," relates George M. Lodge in his *Soldiers in King Philip's War*,

> *Capt. Henchman marched his troops to Dedham Plain, where they halted an hour and were joined by the other troops, and towards dusk, marched on to King's Bridge of the Neponset River, where an eclipse of the moon so upset the men they declined going further.*

Evidence suggests that "Dedham Plain" was present Readville. "King's Bridge" was the present site of the bridge at the George H. Morrill and Co. ink mill in Norwood.

The rest of the story comes from a book written by a minister in Ipswich, Massachusetts, in 1677, the year after this happened. It is W. Hubbard's *A Narrative of the Troubles with the Indians in New England*. The quotations are the parson's.

It was an eclipse "which occasioned them to make a halt, for little Repast, till the moon recovered her Light Again." Some of the soldiers would not be persuaded but that the eclipse, "falling out at that Instant," was ominous. Some professed to be able to discern "an unusual black Spot" in the center of the moon, which looked like an Indian scalp. Others saw an Indian bow. But they managed to get over their fears, and "after the Moon had waded through the dark Shadow of the Earth, and borrowed her light again," by the help thereof the two companies marched on toward Woodcock's House, thirty miles from Boston, where they arrived the next morning.

When you cross the ink mill bridge next time, think of those "souldjers" crouching in terror along the post road in front of the present Willard Dean House. It was not until three years later, in 1678, that Ezra Morse built the first mill and house in present Norwood, the latter on the crest of Morse Hill. When this eclipse occurred, our Norwood was a totally unsettled wilderness.

But at last, we have a true Indian story.

TIOT'S FAMOUS TURNPIKE

Originally published on March 26, 1935

The first great national influence that shook Norwood out of its post-Revolutionary lethargy was the opening of the Norfolk and Bristol Turnpike in 1806. This was one of the earliest of a network of privately built roads that connected most of the trading centers of the original thirteen states.

Crude and bone-shaking stages had been floundering and floundering thru the old post roads, bound for such foreign cities as Boston and Providence and such legendary towns as New York and Philadelphia. They were little used by the frugal Norwood farmers. Soldiers had gone, and returned with tall tales over these post roads to settle down for life on the old farm. Distant wars, which never actually touched Norwood, had been won. Still, this hamlet of dour, rather humorless, thin-lipped grangers slumbered on. South Dedham Parish, like hundreds of other little communities, was a self-centered and self-contained village, with little apparent need of good roads and not the slightest conception of what a fine road was or could mean to civilization.

Just remember our local colonial roads as a simple triangle. Its eastern side was the old Roebuck Road (Neponset and Pleasant Streets). This formed an angle down in South Norwood at what is now Willow and Pleasant Streets. Then this Guild Street side of the triangle wandered up the hill to present Lenox Street and more or less followed the latter until it turned west at its present junction with Cross, meeting at the Old County (or Old Providence) Road, which was our present Walpole Street, at the point Guild and Walpole Streets meet today. This was the second angle of the triangle. The Old County Road then completed the triangle by running, with many a curve, in a northerly direction to meet Old Roebuck in the third angle of the triangle at the present corner of Washington and Neponset Streets. You can think of this triangle traversed by a few crude cart paths, joining the farms with the three main roads of the triangle, which were only a couple of degrees better than the cow paths. That was Norwood's road system up to 1806.

Slashing across our triangle, like a giant arrow shot due south from Boston, came the Norfolk and Bristol Turnpike, which was commenced in 1802 and opened for traffic in 1806. At that date, it was one of the three best highways in the United States. Albert Gallatin, secretary of the U.S. Treasury, wrote in a report on turnpikes to Congress in April 1808:

> *Several of a more expensive kind have been completed, particularly in Massachusetts. The cost has varied from $3,000 to $14,000 a mile, and amongst artificial roads of the first grade may be mentioned those from Boston to Providence, to Salem, and to Newburyport.*

Norwood woke up to find itself on a national highway, the like of which it had never dreamed!

The egg from which our Massachusetts turnpikes sprung was a little building on the banks of the Charles over in Waltham. It was the first American

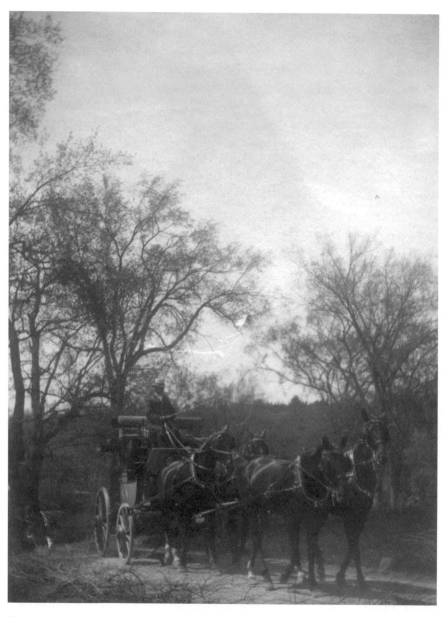

Stagecoaches such as these may have traveled over the old Norfolk and Bristol Turnpike. Amtrak was about two hundred years in the future. *Photograph courtesy of the Norwood Historical Society.*

cotton factory. Industrial plants began to spring up like mushrooms shortly after 1800 on almost every river and powerful stream in New England. It was to bring manufactured articles to the smallest towns in the United States that the turnpikes were built. The first one, "the Cumberland Pike" was to open the pent-up West to the East and South. The farmer need no longer make everything he used. It was the beginning of a great inland commerce to tie in with our rapidly developing maritime business, which was to culminate in the '50s with the swift, globe-circulating clippers. We were viewing the dawn of that age when a new Yankee aristocracy was to build its fortunes on "rum, slaves and molasses," plus wooden nutmegs and shoddy army uniforms. And to be just, on some of the finest and most honestly fabricated merchandise ever turned out in this country.

The inside history of how the Norfolk and Bristol Turnpike was built, and the men who did it, is fascinating, but long. Space forbids much mention of it here.

Only once did this corporation condescend to file a return of its doings as required by its charter. In that, the total cost of the road is stated to have been $225,000, which makes the cost per mile about $6,440. This figure was undoubtedly inflated as we have plain evidence that the total capital was only $192,800; and taking the latter figure as the cost of the road, it would give a cost per mile of about $5,500. This was 40 percent less than the cost of the Salem Turnpike.

The overhead costs included the purchase of the land and land damages, labor, the building of all bridges and tollhouses, side drainage and everything else that goes into the cost of road making. But the chief increase in cost over former roads was the surfacing of the Norfolk and Bristol with a stratum of gravel or pounded stone. This was a twenty-four-foot-wide road—ample space for two teams, a highway that was revolutionary in its comfort and speed.

No longer would it require ten hours to reach Providence and the rest of the week to get to New York. The Age of Speed was here! In 1832, the average record run from Boston to Providence by stage was four and a half hours. The fare was three dollars per person.

The Massachusetts custom was to allow the erection of toll gates at intervals of about ten miles. In South Dedham, the first toll gate was called Ellis Gate—the entrance to the South Parish from Dedham Village. Another gate stood at the crossing of the Neponset River below South Walpole.

About the time of the United States centennial celebration in 1878, a concentrated movement resulted in having the old turnpike renamed Washington Street in all the Massachusetts towns through which it passed. It

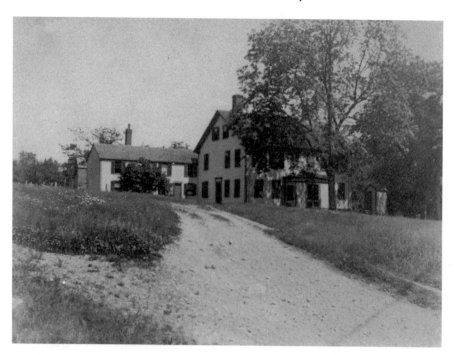

Above: This house, located near today's Route 1A and Clapboardtree Street, served as a toll station called "Ellis Gate" on the Norfolk and Bristol Turnpike. *Photograph courtesy of the Norwood Historical Society.*

Right: This stereograph is of Washington Street looking south from Nahatan Street. Village Hall and the First Baptist Church can be seen on the left. *Photograph courtesy of the Norwood Historical Society.*

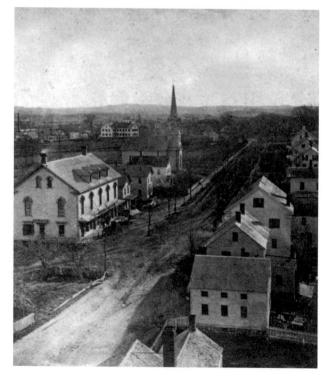

ran from the corner of Washington and Bartlett Streets in Boston, through Forest Hills, the site of the first toll gate on the route. From Dedham Center to the Rhode Island boundary is the old turnpike. It was pretty straight through Norwood and East Walpole. But from the latter's present reservoir to the state line, it was considered an engineering and surveying marvel.

SPIRES RISE IN TIOT

Originally published on October 16, 1934

They have been called "white fingers of Faith, pointing Heavenward," those lovely, slender spires of New England silhouetted against the green elms. But those of us who love our New England with that family affection, which loves the faults as well as the virtues, we smile a small, sardonic grin 'way up our sleeve.

Fingers of faith they certainly were in Puritan Massachusetts and South Dedham. But they were also stern, upraised fingers of Authority. Who are we of this soft and luxury-loving generation to judge the excellence of the bigoted, self-denying forthright philosophy of the first church organizations of South Dedham—the Congregationalists? Overly pious they were, perhaps, but they were human beings just like ourselves. Scratch the surface of the church records of the Congregational Society of Norwood, and you will find beneath the bid of the Puritan all the virtues and sins of us Norwood folks.

Now begins the weaving of that many-hued fabric that we call the church life of our town. The webs and woof of ever-growing and extending creeds, influencing smaller groups instead of all our citizens.

Think of the South Dedham of 1827 as a large family. There were ninety-five poll taxpayers. Everyone knew everyone else in town, their smallest virtues and faults, their peculiarities, their salaries, their genealogy. Imagine also the honest, stern, outspoken, narrow-minded and obstinate father of this family—the Orthodox Congregational Church. There were many sons and daughters in this family, young married couples especially.

These younger people, for several years prior to 1827, had begun to react to the great wave of unrest against the old church domination that was sweeping all New England. Yet this South Dedham group hesitated long to separate from the old church. And well they might! It is hard for us today, with all our nationwide tolerance, to realize what this family rebellion of the younger sons and daughters meant. It would mean that next-door neighbors, hard-shelled Orthodox, would quit speaking to them on the street and would

even cross over so as not to meet the rebel. It would entail the loss of business and business advancement. Each rebel would be ostracized, scorned and made fun of. Finally, this group bravely decided to leave their church home forever. It required exactly the same courage as the Pilgrims and Puritans exhibited when they quit England.

In the spring of 1827, twelve men met in solemn conclave at the tavern of Joseph Sumner, the old Norwood House. Everyone was a solid citizen. Several were leaders in civic affairs. They debated long and earnestly whether they would become Unitarians or Universalists. They decided to be Universalists. At a later meeting on October 22, 1827, the first regular meeting of the First Universalist Church of Dedham, with the incorporation papers all signed, was held in Joe Sumner's tavern with these same twelve men in attendance.

There is no use in digging up the bones of that forty-year uphill battle that the Universalists grimly and bravely waged to establish their church belief and personal ideals in their community. And yet, I must touch on it. They got no help or sympathy from the Orthodox society. In the beginning, the latter did everything it could to hinder the success of the new movement of liberalism, and to make the upstart, new-fangled liberals feel uncomfortable and out of place. This attitude later gave way to a cold aloofness and smug superiority, as the new church held on and slowly grew in spite of all the unexpected hurdles it had to leap.

In 1863, another bright thread appears in the weaving. Not a new spire, but a new strand of belief attached to the old Universalist church building. Those of the Catholic faith, who had been walking to Roxbury and Canton to Mass each Sunday, bought the first Universalist building for a Catholic church in South Dedham.

Just where the Holy Sacrifice of Mass was first celebrated in South Dedham seems to be in some doubt. It seems probable that Father Patrick Strain made a visitation to certain Catholic homes of South Dedham in 1843. There is a tradition that he celebrated the first Mass in a barn that stood on what is now Mylod Street, at which only nine women were present.

At all events, from 1863 to 1889, the South Dedham Catholics worshipped in their own church. And in the later year, in their own parish when St. Catherine's Parish was set off from Dedham, thanks to the efforts of Reverend Robert Johnson. On October 12, 1908, the work of building the present magnificent structure of St. Catherine's Church was started.

A fruitful period, this, for spire builders! In Union Hall, the people of the Baptist faith held their first public meeting on August 8, 1858. In November of the following year, Reverend Joseph B. Breed was called as pastor. On December 1, 1859, their church was dedicated—the same edifice that stands

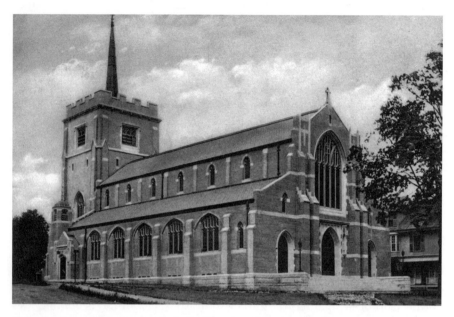

St. Catherine of Siena Roman Catholic Church, built in 1910 at the intersection of Washington and Nahatan Streets. The parish dates back to 1863. *Photograph courtesy of the Norwood Historical Society.*

so prominently and solidly on Washington Street today [1934]. But the first ordinance of baptism by immersion was administered to a "Brother Messer" in old Union Hall on January 2, 1859. This hall was also used by the Catholics, as well as Village Hall, for services until their own church was obtained and remodeled.

Why did so many spires rise all at once? The answer is largely in the shriek of the first passenger-train locomotive that shattered the peace of South Dedham Village as "the cars" rattled in from Dedham over the Norfolk County Railroad on April 23, 1850. On that date, Norwood was engulfed in the beginning of the first boom of the United States. New people, new ideas, new faiths and new money began to trickle into the village in ever-increasing numbers. Like everything else, the pattern of church life was tremendously changed from its past cut-and-dried form. For South Dedham stepped from the role of a farming community to that of a manufacturing center.

On June 22, 1887, the Methodists organized at their first legal local meeting at the residence of Joshua Gill. On July 11, they bought land on Day Street for a chapel, paying $600. In 1888, they finished and occupied the building. The church was actually started in 1874 by a few Methodists and some seceders from the younger group of the Baptist Church. Meetings

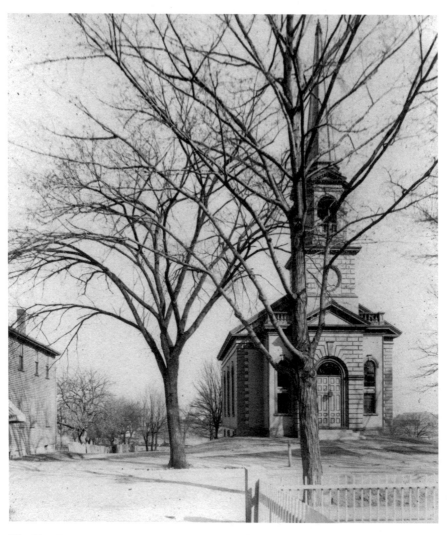

The First Baptist Church, at the corner of Washington and Vernon Streets, was a landmark in Norwood for years until it was torn down in 1950. *Photograph courtesy of the Norwood Historical Society.*

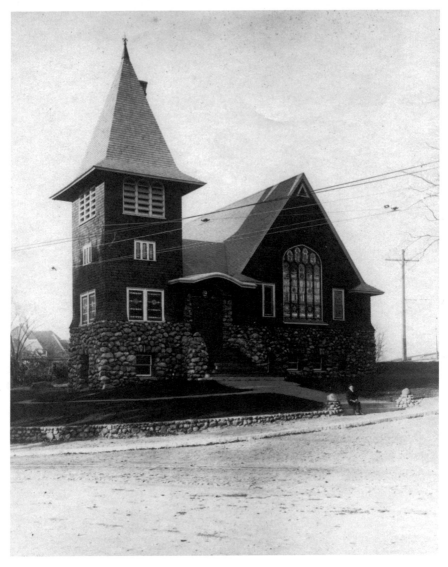

Norwood's Methodist Church, located at the intersection of Washington and Walpole Streets. Its congregation dates back to 1887. *Photograph courtesy of the Norwood Historical Society.*

Birth of a Community

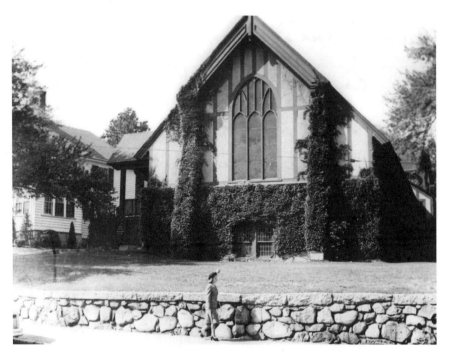

Local Episcopalians traveled to Dedham for worship until the construction of Grace Episcopal Church on Washington Street in 1907. *Photograph courtesy of the Norwood Historical Society.*

were held in Village Hall, with preachers from Boston University. In 1877, many of the seceders having returned to the Baptist fold, this first Methodist spire tipped over. The Methodists worshipped in their little chapel until December 31, 1900, when they held their first quarterly conference in the vestry of their new church, which stands today [1934] at the junction of Washington and Walpole Streets.

Norwood Episcopalians also started to form a parish in 1888. But it was not until about the year 1907 that it was actually accomplished, those of the faith going to Dedham to worship in the interim. The present building of the Grace Episcopal Church on Washington Street was built at that time.

The minister called at the opening of this church was the Reverend Charles Hastings Brown, and he has faithfully administered the affairs of Grace Church until the present time [1934]. This record of service not only makes Mr. Brown the dean of the Norwood clergy, but it is also unquestionably longer than that of any other minister who had occupied a South Dedham or Norwood pulpit.

There we close an epoch of almost two centuries of spire building in this little community. Have you, from this all-too-inadequate sketch, glimpsed the rich color effect in the tapestry that our busy spires have been weaving?

THE LIBERTY BELL OF TYOT SHALL NOT RING OUT TONIGHT

Original publication date unknown

Chapter 1. The Whittler

"So we can't ring her on the Fourth! Is that right, Ed?"

Captain Edward P. Twitchell of Washington Fire Company Number 7 gave a vicious jerk and muttered, "Yes, damn it! That's right. And dog-gone wrong, too! Don't you think so, Mark?"

Mark Alden tipped his chair forward from the firehouse door with a bang and squinted through the gathering dusk at his captain.

"Yes, I do, Ed. What's the reason?"

Captain Twitchell sucked morosely on his dead pipe and made no answer. A third figure, sitting on the other side of Twitchell, knocked a glowing

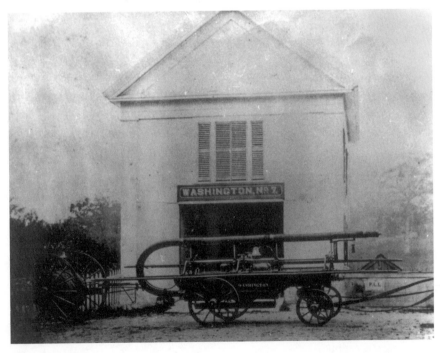

Volunteers from Washington Fire Company No. 7 initiated events that led to South Dedham's split to become the town of Norwood. Pictured is "hand tub" number 7. *Photograph courtesy of Jim Flaherty and Steve Lydon, Norwood Fire Department.*

shower of sparks from his pipe and replied for him. It was Henry F. Shattuck, clerk of Number 7.

"Because, Mark—and you know it—those damn selectmen down at Dedham Village are ridin' the South Parish again, just as they have ridden it ever since I can remember, and long before that, too. We are forbidden to ring our fire bell this Fourth of July simply because those bigwigs know it will make South Dedham mad. Struttin' their authority like a lot of turkey gobblers! No other reason at all!"

Another figure at the end of the line whittled on a shingle. The shavings snapped off with a brisk click. Had the light been strong enough, it would have been evident he was a young man, just out of boyhood. A stocky youth, with a full face and hard, straight, full lips. His drooping eyelids gave his countenance a sleepy look. During all the conversation, he had not spoken or moved, other than the rhythmic swing of his keen knife.

"You're right, boys," Captain Twitchell replied. "Tain't just. But I guess it's true. I was to Dedham this afternoon and a friend of mine told me the selectmen really did vote we shouldn't ring our bells in South Dedham this Fourth. I ain't got any official notice yet, however. So I guess, George Metcalf, you won't have to get up as early this Fourth as usual. No bell ringers needed!"

The whittler shaved his shingle delicately and said in a soft and hesitating voice, "Sam Pond wasn't at that selectmen's meeting, George."

George E. Metcalf, the company's steward, stuck his head out like a turtle toward the motionless boy and remarked quietly, "What's that, Frank?"

The other men swung their eyes toward the quiet woodcarver. Frank Fales was one of the youngest members of the company. He had come in two years before, in 1866. This was July 2, 1868. Yet, in those two years the members of Company 7 had learned to listen when Frank Fales said anything. It usually was small in quantity but pregnant in quality.

Again, the hesitant voice came thru the twilight. "Yeah, George. His son's horse has a bad case of epizoot. Had it two days." *Snap!* went the shingle.

The group was utterly silent. "Hum-m-m!" murmured George, softly, as to himself.

The captain and Henry Shattuck got up with the air of corporation directors who had just sat through a difficult board meeting at which a big deal had been consummated. Their whole attitude was one of relief. Frank Fales quietly rose with them, snapped his jackknife shut and put it in his pocket.

"Goin' home, Cap?" he asked Twitchell. "Get in my buggy. Give you a lift."

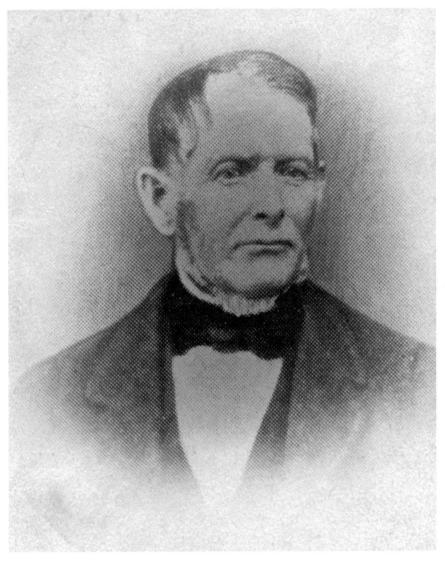

Sam Pond, South Dedham representative to the Dedham Board of Selectmen. *Photograph courtesy of the Norwood Historical Society.*

Birth of a Community

Chapter 2. The Frame-Up

In 1868, the South Dedham Post Office was located next to L.W. Bigelow's store in Village Hall. George Metcalf was part proprietor of the South Dedham Hotel, just north up Washington Street. So it was easy for him, the next morning, by sitting on the front piazza, to keep an eagle eye on the big, vertical tin drum upon which Postmaster Willard Gay stuck the village mail under the initial of the recipient. The chance was good that practically every voter in the village would spin that drum sometime during the morning or afternoon of July 3, 1868.

At last, like a tiger coming to the watched water hole, South Dedham's representative on the Dedham Board of Selectman, Sam Pond, crawled out of his buggy and hitched his horse to the massive iron hook originally set up for the turnpike stage drivers to throw their lines over while wetting their whistles at the tavern bar. This hook gave the village center its nickname. As Sam stepped onto the low piazza in front of the tavern door, George Metcalf, with the greeter smile of Mine Host, strolled up to him.

"Mornin' Sam!"

"Mornin' George."

"Where you been keepin' yourself, Sam? Ain't seen you for a week!"

"Not so bad as that, George. 'Bout two days, I guess. Been havin' a hell of a time with our hoss. He's sick with this here epizoot. Sicker'n all get-out, too! Me and the boy' scared to death he's goin' to die. And we need him right bad right now to haul down to the tannery. Good deal o' freight pilin' up on us."

"Gosh! That's too bad, Sam! You better stay right by him and get him cured up quick."

"Yeah, you're right, George. I don't expect to leave him until we either bury him or harness him."

"By the way, Sam, I suppose you want me to ring the fire bell tomorrow morning, as usual. You're the boss, you know."

"Fire bell?" A puzzled look came into Sam Pond's pale blue eyes. "Fire bell? Oh, yes! Sure! Fourth of July! Hah! Been so dang worried I don't know if it's July or January! Sure, George! You ring her good."

Chapter 3. The Fight

Ding! Dong! DING! DONG! Ding! Dong!

The silvery-sweet voice of the Number 7 bell, with its traditional note of alarm and terror, rang through the damp, scented air as the first faint beam of sunrise stole over South Dedham. It was July 4, 1868.

Samuel Howard, sixth assistant fire engineer of South Dedham, village constable and station master at South Dedham Depot, heard the bell from the depths of that deathlike sleep that precedes awakening. He was in his bed in the old Howard homestead at the corner of Howard and Washington Streets, one short block north of the firehouse. Sam opened one eye and freed his ears from the pillow.

"Huh! Fire some place!" he muttered, thickly. "Better go, I guess." He crawled unwillingly from the sheets and sat on the edge of the bed, rubbing his head.

Ding! Dong! Ding! Dong! Ding!

A sudden thought struck the constable. He leaped for his clothes.

"Hell-fer-shootin'! It's the Fourth and they are ringin' her! An' the selectmen forbid it! By golly! I'll fix 'em!"

In the dim recesses of the firehouse, on the ground floor near the sturdy tub with "Washington No. 7" neatly painted on its side, George Metcalf was hauling manfully on a rope that ran upward through the ceiling. He was a slim chap, in early manhood, but wiry as a maple sapling. As he pulled the bell rope and the voice of his iron pet above answered joyously, a boyish grin, mingled with adult malice, illuminated his face.

Footsteps came running heavily to the open door. Sam Howard shot thru it.

"Hi you! George Metcalf! Stop ringin' that bell! Stop it! I tell you! In the name of the law—stop it! Don't you know the selectmen have forbidden it?"

George ran nimbly around to the other side of the tub, swinging the rope with him.

Ding! Dong! Ding! Dong! Ding! Dong!

"No," he shouted above the din, "You must be crazy, Sam! I got orders to ring her!"

"An' I got orders not to let her be rung! That she can't be rung!—letter from Dedham up to my house," panted Constable Howard, rushing around the tub himself.

George again reversed the play and was back on the other side.

Ding! Dong! Ding! Dong!

"Go on, Sam!" he panted. "Sam Pond told me yesterday to ring her and ring her good. So—I'm doin' it!"

Ding! Dong! Ding! Dong!

Sam Howard, a large, heavy and muscular man noted for strength and fearlessness, glanced around the firehouse. His eye fell on one of the long poles with an iron hook on the end, used for pulling down burning buildings.

Birth of a Community

He grabbed it and, swinging it over the tub, managed to gaff the bell rope. A twitch, and he got a turn of rope around the hook. Then he threw his full weight on the rope. For an instant it held. Then it snapped, and the coils fell in festoons around the body of George Metcalf.

As he struggled to disentangle himself, Sam Howard came charging around the tub and plunged into George, pushing him, staggering, toward the open door.

"Get the hell outta here! And stay out! Understand? That bell don't ring any more—Sam Pond or no Sam Pond."

Before he had the words out of his mouth, George had shot by him and was bounding up the stairs to the second floor.

The second story was the company meeting hall—a little room, capable of seating forty men. There was a small platform at the west end. And on the east side, a ladder ran up the wall to the belfry. As Sam Howard pounded up the stairs, George skipped up the ladder like a mischievous monkey. By the time Howard had reached the top of the ladder, George had the trapdoor beneath the bell unbolted and was through it, looking down.

"Now listen, Sam! Don't come no further! I got orders direct from Sam Pond yesterday to ring this bell today. He's my boss, not you. He's your boss, too. The selectmen ain't told me not to ring this bell—and so I'm goin' to ring her just as long as I dang please. If you come up any higher, I'll kick your teeth right down your gullet. I don't want to, Sam. But I'm warning you. And I'll do it!"

Sam Howard went slowly down the ladder, a bewildered and baffled man. George bolted the trapdoor and swung the heel beside the bell. It tipped. The iron tongue took up its interrupted rejoicing at the victory of the Yank's Revolution over the British.

There was also an overtone of triumph at the victory of South Dedham over Dedham Village.

A voice bellowed up from the street. "All right! You fellers will be sorry for this morning's work! Mighty sorry!" Sam Howard trudged homeward— another Fourth of July ruined.

Ding! Dong! Ding! Dong!

Chapter 4. The Uprising

Three days have passed. The scene is the meeting hall of Number 7 fire company. It is a hot July evening. Hanging kerosene lamps smoke and sway. Moth millers and June bugs swirl above the heads of the thirty-nine members, sitting tense and quiet as Captain Twitchell, presiding, opens the meeting.

In Clerk Henry F. Shattuck's neat handwriting we have the clear skeleton of this historic meeting upon which our imagination can build the picture:

> *The records of the last meeting were read and approved.*
> *Voted: To send a petition to the Selectmen of Dedham, asking for the removal of Samuel Howard, 6th assistant Engineer.*
> *Voted: To choose a committee of three to circulate two petitions. One to the members of the Co., the other to the citizens of South Dedham.*
> *Voted: That the Company return their thanks to the members that rang the bell on the Fourth of July.*
> *Voted: To adjourn. H.F. Shattuck, clerk.*

From this meeting until the next, all South Dedham buzzed like a hive of angry bees. No one is now living who experienced the thrill of this, the actual beginning of the revolt against Dedham. No one, except Willard Dean. And he remembers nothing. All we have definitely is the plain evidence of Henry Shattuck's next report:

> *A special meeting of the Co. was held Aug. 11th at 7 o'clock P.M.*
> *A communication was received from the Selectmen as follows:*
> *Voted: that we do not consider the charges preferred against Engineer Samuel Howard by firemen and citizens to be sufficient to justify us removing him from office.*
> *Voted: That we also consider that Mr. Howard was* **indiscreet** (the boldface is Shattuck's in the original) *in using force against Mr. Metcalf, a member of the engine company, and we hope we shall not be called upon again to consider a similar charge. By order of the Board, John Cox, Jr., Clerk.*
> *C.H. Rogers and E.E. Shumway were appointed to wait on Samuel Howard to ascertain if he had resigned. They reported that he had resigned.*

Chapter 5. The Die is Cast

In the last scene—again the meeting room of Number 7—the die is irrevocably cast. What was to happen four years later in 1872, when South Dedham became Norwood, throws its grim and angry shadow clearly across this little meeting of firemen.

To understand it, you must remember that for three years, from the day the boys came back from the Civil War in 1865, all of Dedham had been

planning the erection and dedication of its Memorial Hall. It was, I think, the first war memorial ever built in the town. It stood for a town's bitter anguish, blood, death, self-sacrifice, gallant bravery and high patriotism. For every man, woman and child in Dedham, the grimy old hall still standing on Dedham Square was a living symbol of a great terror, only recently escaped. South Dedham was as much involved in its meaning as any other part of the community. The names of South Dedham's soldiers were inscribed upon its memorial tablets in letters of gold.

Again, there is a full meeting at Number 7. Captain Twitchell presides. Members sit in motionless silence, hands in laps, faces straight ahead. Every man knows what is to be done. Everyone is a well-known, responsible citizen. They, the oldest secular organization in town, representing the rest of the citizens of South Dedham, are about to show the mother town the sum total of generations of slights or fancied slights, the petty meanness of a town feud. Tyot, at last coming into its own as an independent community, is about to speak.

The meeting drones on and on. Men are given honorable discharges. New members are voted in.

Captain Twitchell clears his throat, "Gentlemen, I have here a communication from the secretary of the committee of arrangements for the dedication of Memorial Hall, inviting the company to attend the ceremonies. I await your pleasure. Do I hear a motion?"

In the rear of the hall, George Metcalf shuffles his feet and pushes back his crude kitchen chair as he rises. Its scrape cuts the dead silence like a bow.

"Mr. President, I move that the company does not attend the dedication ceremonies of Memorial Hall." George Metcalf sits down, his work completed.

"Do I hear a second?" said Captain Twitchell.

As one man, the company thundered, "Second it!"

And Henry Shattuck wrote: "Voted: Not to attend."

Author's note: The vital facts of this story are historically accurate. The conversation is necessarily imaginative.

FARMS TO FACTORIES

These selected "Tales of Tyot" depict the citizens of South Dedham (soon to become Norwood) riding the crest of the Industrial Revolution. Here, Win Everett gives us a collection of valuable local history lessons as he describes Norwood's transition from a purely agricultural farming society to the busy industrial town of the 1930s.

TIOT'S FIRST CATTLE SHOW

Originally published on December 4, 1934

Between September 26, 1849, and September 1868 the one blazing red-letter day that everybody in eastern Massachusetts and South Dedham ringed on the calendar was the Dedham Cattle Show. Or, to give it the official title appearing on the program:

> *The 3rd annual cattle Show and Fair of the Norfolk Agricultural Society, will be holden at Dedham on Wednesday, Sept. 24, 1851. The Trustees invite the Agriculturists, Mechanics, Manufacturers, Horticulturists, and Ladies of the County to join their endeavors to render it worthy of the patronage of the Commonwealth, and creditable to themselves.*

That ought to give you an inkling that here was no racket. They took their cattle shows straight and seriously. Before 1840, the average New England farmer was running his plant just as his dad and granddad did. "If it was good enough for them, etc. etc." But the railroads had just arrived. New

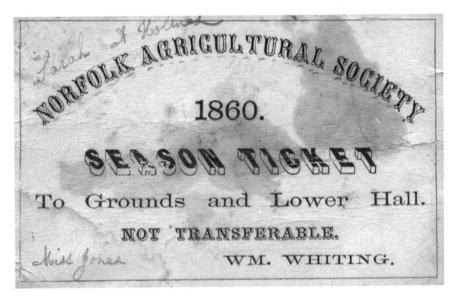

A season ticket for the Dedham Cattle Show of 1860. *Courtesy of the Norwood Historical Society.*

ideas and the bubbling yeast of progress were rolling by the farms. There were men, known as "fancy farmers" or "gentlemen farmers" by a cynical and grinning peasantry, who were spending large amounts of money to learn how to double their crops and improve their breeds. The infant industry of farming machinery was in diapers.

This first Dedham Cattle Show in 1849 was a historic white stone at the very beginning of that titanic wave of farming on a big scale that swept from Dedham to the foothills of the Rockies and to the Gulf of Mexico—the bedrock of most of our history that has been written since that date. It was deliberately organized by prominent and farseeing men of Norfolk County to tie together all these new influences for the betterment of themselves and the farmers of the county. Quite naturally, it was held at the county seat. And equally naturally, the men and women of Dedham had a large hand in the doings. But you of Norwood need not stick out your chests because little South Dedham was always soft pedaled by the pooh-bahs of Dedham and never allowed to play even a piccolo in the official band. More of that anon.

The scene of the Cattle Show was the Common, then and now known as "Connecticut Corners" because some tinsmiths from that state came to work, in 1800, in a shop at the corner of Lauder and High Streets, Dedham. These "foreigners" were, of course, marked men and well hated by Dedham

citizens, who little realized that what was then a dirty crack would become a geographical term in their fair village.

One can see in the immediate foreground a number of buses and swanky two-horse drags or coaches. Also a great flock of those good old "carry-alls," or the family vehicle that was used to take all the folks to any affair. They look like black, square boxes on wheels. Little windows appear on the side curtains. Some of them have doors and steps on the rear, though others are closed tightly. And buggies, of course, fill all remaining parking space.

Swarms of visitors are strolling thru the gates westward into the fairgrounds. The men wear tall, silk hats and carry canes, while clad in long-tailed dress coats. The women are in their best bib and tucker—wide sweeping skirts, shawls and bonnets. While the artist has lied about the children, who are pacing as sedately as their stuffy elders, each and all are pressing forward between the rows of simple booths and pens beside the hall. It was after this picture was drawn that the racetrack was built on land that was deep in the western part of the fairgrounds. Here our Tiot citizens saw their first trotting races. Here was the great-grandfather of the Norfolk County racetrack, which may someday grace our Fowl Meadows.

The following notes from the diary of Mr. Henry W. Richards of Dedham will perhaps, now, be clearer to you:

> *The first annual cattle show took place today and was attended by as many, if not more, people than ever were in Dedham, at one time, as estimated by some at 10,000. The weather has been propitious as could be wished, excepting that it was very dusty. The exhibition comprised fruit and flowers at Temperance Hall, vegetables and manufactured goods at the silk factory, cattle at the large Common and ploughing and drawing matches in its immediate vicinity.* (Sort of scattered, wasn't it?) *At 11 o'clock I joined the procession on the common and marched to Dr. Lamson's church* (the First Church) *where an address was delivered by Col. Marshall P. Wilder, president of the society with other suitable exercises and prayers. The procession was then reformed and marched to the collation which was served at the silk factory.*
>
> *At the table the toasts were given, which brought further replies from Gov. Briggs, Daniel Webster, Edward Everett, Robert C. Winthrop, Levi Lincoln, Horace Mann, Josiah Quincy Jr., Charles Francis Adams, Dr. Lamson, Edward L. Keyes. At 5 o'clock after the dinner, the winners of the premiums were reported at the church. The exercises of the day closed with a ball at the Phoenix House which was numerously attended, occupying two halls till 2 o'clock in the A.M. Notwithstanding the immense gathering today, everything passed off with the utmost order and decorum.*

I have called that first cattle show a historical milestone. When you consider that its banquet was attended by the governor of the state, by the most famous orator and lawyer of the United States, by the president of Harvard University, by the pioneer of all modern American education and, even then, a famous pedagogue, by the descendant of a president of the United States and by another presidential descendant who was to write a book that has become an American classic, you may agree that the milestone was suitably engraved and decorated. It also proves that the Boston of 1840 was the intellectual hub of the universe. Also, that it was easy to corral a group of mental giants, fifteen miles out in the wilderness from Boston at a cattle show, which could scarcely be duplicated today for quality at any national event.

And where was South Dedham in this cattle show jigsaw puzzle composed of our country town? Well, after looking through two big record books of the secretary and treasurer of the society, and several fat annual reports of details from 1854 onward, I should say that Norwood was given the well-known razz-berry. And not as a horticultural prize, either.

It is laughable to see how the ancient contempt of the "better minds" of Dedham for the chuckle-witted poor relation of the South Parish sticks out here and there in these cattle show papers! Never, by any chance, was there a South Dedham man of the imposing board of officers—at least, not in those I checked. And though I searched diligently, I did not find many premiums for exhibits going to South Dedham. Instead, one finds snooty little barbs like this: "The knit socks of Mrs. Farrington of South Dedham would have received a premium had they been sent Tuesday, the day before the fair." Or this: "Boyden & Co., So. Dedham, Cabinet Work. Had it been offered in season it would have been more distinctly noticed." No, every little jerk hamlet in the county except Norwood seemed to be in the money. But I noticed they were glad enough to receive the membership fees from South Dedham men, most of our prominent citizens joining at some time during the life of the society.

In her diary, on September 29, 1854, Mrs. David S. Fogg, of South Dedham, writes:

> We went with the children to the yearly agricultural fair at Dedham. They love to see the little pigs, lambs, calves etc., and "The Fandango" astonishes their eyes, and the band of music charms them. There is always a great collection of people to witness the racing, which is very amusing, especially to gentlemen and to some ladies who must pretend to be interested, if they are not.

Mary B. Fogg (Mrs. David S. Fogg) recorded her memories of life in South Dedham in journals and a number of scenic paintings, now in the collection of the Norwood Historical Society. *Photograph courtesy of the Norwood Historical Society.*

This "Fandango" she mentions was the original Ferris wheel. It stood about thirty feet high and had wooden seats, like sleighs, holding two people. Two men ran it by hand power. During one cattle show, a sudden thunder storm came up. The Fandango was full of couples. The bottom dropped out of the sky, and the Fandango operators worked madly to get the customers down. Finally, with one couple high in the air, the manpower quit and ran for shelter. After the storm subsided, they lowered a lady, who had been clad in a beautiful white muslin dress and straw hat with blue ribbons, with her beau, who had his only store clothes on. What they said to the Fandango people was not repeated in the meetinghouse next Sunday—at least, not in the pulpit.

STAGECOACHES OF TIOT

Originally published on April 9, 1935

"Old Roebuck Road" or "the Country Road," our very first post road, which is now our present Pleasant Street, was too rough, hilly and winding for stagecoaches. Think of it only as primitive road for riding horses and ox carts. Stagecoaches came to Norwood in 1767, when the first stage line between Boston and Providence was established by Thomas Sabin. They came from Wrentham by way of Walpole Street, called "Old County Road." This was our first stage route—the great Revolutionary stage route between Boston and Providence. From 1767 onward, Old Roebuck was practically abandoned except for local use by the farmers.

Paul Ellis built his South Dedham Tavern on the west side of the Old Country Providence Road to catch some of Tom Sabin's coaching trade. He probably did not have the slightest inkling that a wonderfully improved turnpike would pass the back of his tavern property within a few years after he built. Paul knew it took ten long hours by coach from Providence to Boston. And even if Sabin's coaches did not pull up at the Hook except once a week, which was the case, Paul Ellis found that a ten-hour trip made a man mighty thirsty and a woman fearfully hungry. So, with the transient and local bar trade, a growing stable business for tired horses, plus a small amount of overnight transient trade, Paul, and Lewis Rhodes, his partner, were sitting pretty when the old turnpike broke the front page in 1806.

The real stagecoach era for Norwood opened, of course, when the Norfolk and Bristol Turnpike was finished in 1806. I find no evidence that Paul Ellis had any shares in the turnpike, although he may have invested. But

he certainly had a generous share of the hotel trade it cultivated from Boston to Providence. He could well afford to sacrifice his apple orchard at the rear of his hotel in order to have the turnpike pass on the westerly, instead of the easterly, side of his tavern, where Old County Road ran when the inn was built.

When your back stops aching from thinking of a ten-hour trip to Providence, read about one who perhaps did stop at the South Dedham Tavern. John Melish, in his *Travels in the United States of America*, has the following to say about a trip he made from Boston to New York in 1806. Probably, he traveled the turnpike.

The mail stages here are altogether different in construction from the mail coaches in Britain. They are longer machines, hung upon leather braces with three seats across, of a sufficient length to accommodate three persons each, who all sit with their faces towards the horses. The driver sits under cover, without any division between him and the passengers; and there is room for one person to sit on each side of him. The driver, by the post office regulations, must be a white man, and he has charge of the mail, which is placed in a box below his seat. There is no guard. The passengers' luggage

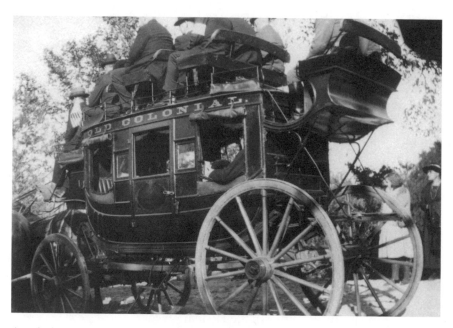

A typical early 1840s Boston to Providence stagecoach run on the turnpike via South Dedham took four and a half hours. *Photograph courtesy of the Norwood Historical Society.*

is put below the seats, or tied behind the stage. They put nothing on top, and they take no outside passengers. The stages are slightly built and the roof suspended by pillars; with a curtain to let down or be folded up at pleasure. The conveyance is easy, and in summer very agreeable; but it must be excessively cold in winter.

The well-known Concord coach was introduced about 1828 by Lew Downing, who had founded the famous house of Abbot, Downing and Co. of Concord, New Hampshire. It immediately sprung into universal popularity, and you can imagine this type in use by the Citizens Coach Line, the Providence Stage and the Dedham Stage line on our old turnpike. Anyone who has seen a shootin' hootin' Western movie knows what this type looked like, for its design has changed little since it was invented a century ago.

Captain Moses Guild seems to have been what Bill Nye called "an enterprizin' cuss," and it is highly probable that he employed some of the famous old Conestoga wagons to haul his silver dollars and freight from Boston to Providence.

SEWIN' STRAW AND MAKIN' HOOP SKIRTS IN OLD TYOT

Originally published on December 31, 1935

If you are a woman, you would do well to give the double house that is now 47 and 49 Cottage Street a Chatauqua salute when you pass it because it was within its old frame that the Yankee men of Norwood grudgingly gave "Wimmen" their first chance to work in a local industry. This building was the straw shop.

Just exactly who built and profited by the straw shop, I have not been able to determine. What information I have has kindly been contributed by Miss Sarah Gay, Dr. Ralph Fogg and Mrs. John Gillooly. Putting it all together, the partial story seems to be as follows. Other facts would be welcome.

Miss Sarah Gay thinks that there were five in the syndicate that started the straw hat business of Tyot. Her father, Fisher Gay was one of the five. I would be willing to bet that Joseph Day had a finger in the pot also. All of the names are probably buried in the Dedham records.

The business was started in the late '50s or early '60s in a small frame building that was located on Cottage Street land owned by Fisher Gay, the

The house to the left, photographed in 1929 on a quiet winter day, is believed to be Norwood's old straw shop house. *Photograph courtesy of the Norwood Historical Society.*

first general storekeeper of the Hook. When the shop closed, he bought it and turned it into a double house. Captain Bird lived in the east side and the Honorable Warren E. Locke in the other side.

I think it is likely that this straw hat business, which was carried on in villages all over New England, was the logical child of the shoemaking business of that day. This was a home craft, the materials being distributed from the little "ten footers" (shops ten feet square) to many homes, where the whole family often sewed shoes together and brought the partially finished product back to the tiny factory, where it was finished and shipped. The shipping system was often the back of the owner, who, in many cases, was the great-grandfather of some of our highest-scoring golf players.

Women's straw hats were made in much the same fashion. Miss Sarah Gay says she can remember great loads of hay coming to the South Dedham straw shop. Women came to the shop and got this straw; also, the necessary plaster of Paris or heavy wooden hat molds. These were lugged to the home, and there the hats were sewed. Probably, the straw was braided by a few women and girls in the little shop and distributed as braid rather than loose straw. Dr. Fogg tells me that when he was a boy, a Mr. Alfred Tisdale, who lived on the Medfield road back of the Knife Factory (whose cellar, dam, sluiceway and millpond are still visible on that road), used to bring straw already braided to Norwood to ship to Boston and Hartford. He also carried hat molds.

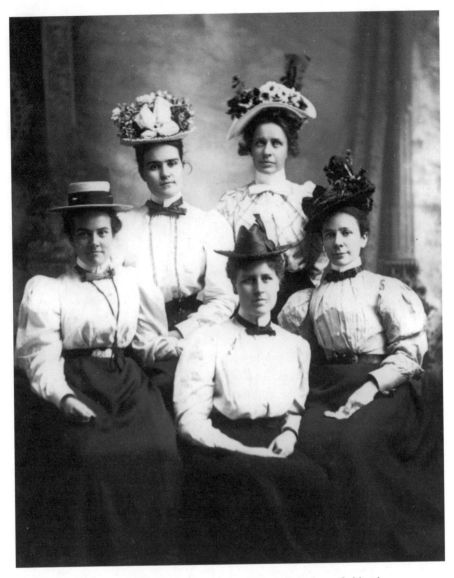

These unidentified South Dedham ladies proudly show off the latest fashion in straw bonnets. *Photograph courtesy of the Norwood Historical Society.*

The doctor also asserts that a Mr. Bascom of Medfield took charge of the hat shop when he, the doc, was a boy and turned it into a "steam mill." This means that the business had then reached the dignity of a chief local industry. Mr. Bascom was doubtless a graduate of the Medfield straw-hat business, which later grew into the supporting industry of the town and flourished until the millinery business became a city industry, with women's straw hats fading into a vanishing vogue.

The list of the Norwood women who sewed straw would be a long and honorable one, if we were able to obtain it in full. This is impossible. But it is safe to say that it would contain at least 50 percent of the local ladies between the years of 1850 and 1870. There were precious few families hereabouts in those years who were so well-to-do that the mothers and daughters were ashamed to be seen "sewin' straw" to pick up a few extra dollars. What the pay was I do not know, but it is safe to say it was wretchedly low. When you consider it was the first pay envelope any Norwood women had, it was doubtless considered fair pay and a real godsend to many a struggling family.

The method of sewing was interesting. The braided straw was put in a bucket of water to soak. Then the mold was held in the lap and the hat started in the center of the crown on the top of the mold. The straw was, of course, sewed around in concentric circles, working it over the edge of the crown and tightly down the sides of the mold to get the shape. When the head of the bonnet was thus sewed, a separate piece was sewed on for the flaring edge and the outside edge neatly finished. Then the mold was set away to dry. When the dry straw was removed from the mold, the shape of the hat was fixed.

Another fashion industry that followed the straw shop in our town was the Hoop Skirt Factory. The details of this are practically lost, as far as the writer can find out. The only man who remembers anything about it is John Gillooly. It was started about 1870 in Odd Fellows Hall, which was also called Hartshorn's Hall, located in the north end of the Dick Hartshorn Norwood House, or the old South Dedham Tavern. Here were fabricated those enormous birdcages in which the ladies of the Sad Sixties delighted to, more or less, conceal their legs. Having seen many movies of the hoop skirt plays, it is the writer's opinion that the ladies of the sixties put a fast one over on the deacons when the ostensibly "modest" hoop skirt was put into vogue. Be that as it may, the Norwood crinoline shop seems to have been an outgrowth of a larger shop in Walpole, which operated in the old building still standing on the west side of Walpole Street, just as one goes down the hill into the center after passing over the railroad. It is now owned by Mr.

Patrick Mahoney [in 1935]. What Norwood ladies worked in the crinoline mill we do not know; nor how long the business lasted. The only one who John Gillooly remembers definitely to have worked at this business was a man—Ned Hare of Walpole. He was a famous ballplayer of his time—a pitcher, I believe.

THE EVERETT FURNITURE MILL

Originally published on June 11, 1935

Deacon Willard Everett, son of Deacon Ebenezer Everett, was born on July 29, 1795, in a plain, well-proportioned farmhouse that stood approximately where James Harding Smith later built his home on the little hill west of Walpole Street on Saunders Road. It was the late eighteenth-century type of house that people are now buying up at fancy prices to "do over" in the colonial manner. The roof was long and sloping, the windows sixteen-paned and I suppose there was a fireplace in every room. A fair-sized barn stood next to it, toward the east. The house faced south on a rough cart path, which led up the hill. The house of Moses Everett, Ebenezer's son, stood across the path, where Elisha F. Winslow later built his house.

Deacon Willard grew up as a hardworking farmer's son. But he must have had a flair for carpentry because he was apprenticed to Jabez Boyden, Tiot's first cabinetmaker, who had a little shop in the heart of Tiot Village on the site of the present ink mill. Here Willard Everett learned his trade. And I suspect the fact that his job was near the ancestral home of Ebenezer Dean, halfway up the Dean Street hill, had something to do with his interest in Lucy Dean, Eben Dean's daughter. Of course, they saw each other in church every Sunday. Anyway, Willard married Lucy on May 27, 1821.

The young cabinetmaker built a home for his bride on a farm that fronted on the Norfolk–Bristol Turnpike, then called Center Street, but now our Washington Street. Its northern boundary is present Hoyle Street and its southern side was Douglas Avenue. Neither street existed when Willard's wedding bells rang, and the farm ambled westward to the Old County Road (Walpole Street) and swung around south to Chapel Street, including "Snake-Up" Pond.

Having a wife and a home, it is natural that Deacon Willard Everett should want a shop of his own, to carry on his furniture business. So he built a small one kit-a-corner [*sic*] across Washington Street from his farm on the northeast corner of Washington and East Hoyle Streets. The latter was a

The Deacon Willard Everett House on Washington Street, where founders of the T.O. Metcalf Press were born. *Photograph courtesy of the Norwood Historical Society.*

continuation of our present Cross Street, there being no car shops then to interrupt it.

As a matter of fact, this Washington Street shop was not Willard Everett's first place of business, although it was the first he erected. He had bought out Jabez Boyden's old shop, where he learned his trade and made furniture for a few years before he built a bigger place for himself.

In these two small shops, Deacon Everett built a good deal of really fine mahogany and black walnut furniture in the slow, careful, hand-made fashion of the '40s and '50s. The writer has several pieces of it, which were part of the wedding furniture made for Mrs. Dr. David S. Fogg. Her son, Ralph, presented them to me because he knew I would prize them for their beauty, as well as their sentimental associations. You cannot buy furniture today with the craftsmanship these pieces exhibit. Willard, and the few men who worked for him, knew his stuff.

Left to itself, I doubt if the Willard Everett Furniture Company would have ever been anything except a small, honest country factory, making largely for local trade and nearby towns. But the deacon had four sons, Willard II, the eldest, George, Edward and Francis. None of them wanted to be farmers, although all did farmhand work on their dad's farm. George and Willard

A hall rack and chair made in the 1850s by South Dedham's nationally known Everett Furniture Company. *Courtesy of the Norwood Historical Society.*

Jr. had young ideas about the cabinet business. They sensed that yeast of greater things, for the sleepy hamlet of South Dedham was already bubbling down at "the Hook" in the erection of the beautiful and stately Universalist church and the astounding phenomenon of the great Village Hall.

Deacon Willard Jr., a very pious young man, died in early manhood (November 27, 1857) and did not live to see "the Hook" swamp the prestige of old Tiot. But George did. He was a canny, farsighted, hard-bitten and hardworking businessman who had traveled enough to know that the world did not end at Worcester, and who realized the trade possibilities of the rapidly growing west beyond the Alleganies [*sic*], as well as the potential demand for Yankee furniture in the Southern states, Cuba and Central America. As his father grew older and died on March 18, 1851, it was George Everett, "the Governor," who slid into the saddle of the Willard Everett Furniture Company and guided its destinies to the day when it all went up in a roar of flames. And it was "the Governor" who took his easygoing, genial, lovable and dog-crazy brother J. Edward, and his brilliant, studious, scholarly but equally gun-loving brother Francis, and stuck their unwilling noses down relentlessly on the grindstone of the furniture mill. At Deacon Willard Everett Sr.'s death, Willard, George and Edward became partners in the business. Francis E. entered it later, about 1859. And under the ceaseless drive of George Everett's salesmanship and modern ideas, it had grown to be quite a considerable business.

The heyday of the Everett Furniture Company was from January 1, 1865, to the outbreak of the Civil War. In that period, they sold mahogany and walnut furniture in every large city in the East and West, to many in the South and much in Cuba and the West Indies. Their specialties were extension tables, the first of which was made in America by the Everetts, with bedroom and parlor stuff. One of their best items in Cuba was immense mahogany and walnut wardrobe closets. Cuban houses had no built-in closets. It was a period when all good furniture carried much caring, and the Everett merchandise had a reputation for it.

When the shop was running full time and at peak production, it employed 280 men. I imagine 200 was an average payroll. Apparently, they had no set payday. A man's pay ran on and was credited on the books. When he wanted money, he went around to the bookkeeper and asked for some cash. While the company was getting interest on this money, it must be remembered they were also banking it for the men, since there was no local bank of any kind.

I have been told that the war crippled the Everett business badly. Like every other Northern industry that was not making war materials, and with its working staff sadly reduced by the demand for men, this company merely

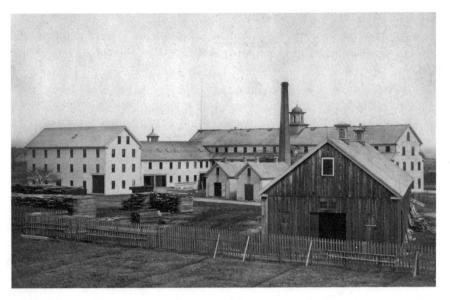

The entire Everett Furniture Company factory, a vital Norwood industry, was completely destroyed by fire in a few hours in 1865. *Photograph courtesy of the Norwood Historical Society.*

carried on as best it could. If the mill had not been destroyed, it would have probably come back, like many another firm, and perhaps Norwood would have, today, one of the largest and oldest furniture concerns in the country.

In 1865, Norwood had two disastrous industrial fires. The worst and most complete one was the burning of the Everett cabinet shop on May 26. On December 12, the Ellis paper mill also burned.

The fire started during the noon hour in the top-floor paint shop. The mill was practically empty, everyone having gone home to dinner. Dr. D.S. Fogg was driving down Guild Street when he saw flames and smoke pouring from the upper windows. It was also mushrooming out of the cupola. The doctor hitched his horse to a nearby fence and rushed into the office, where he found Frank Everett working over the books. He did not know the mill was on fire until the doc told him so. Together, they got the books and papers into the safe and rolled the latter into the street.

In the meantime, the fire had eaten through the roof and had been seen all over town. Of course, the mill was doomed from the start. It was dry as tinder, built entirely of wood, which was soaked with paint and varnish and the floors covered with sawdust and shavings. "America" Engine Company No. 10, the pride of Tiot Village, eventually dashed from its house on Hawes Brook, Washington Street.

In addition to the local "Washington" hand tubs, two came over from the engine house on Clapboardtree Street, Westwood. One of these was about the size of a bathtub and had to be filled by the bucketful by hand because there was no suction pipe. The firemen "sucked into" the cisterns on the property, which were quickly emptied. Then they tried the brook, which ran where the Norwood Press now stands, but it was too shallow to allow suction. And that was the end of the firefighting. The entire plant was a roaring inferno.

After the fire, two hundred or more furniture makers were out of a job, many of them losing their chests of tools, which was a serious loss in those times when a workman had to own all his tools and supply them. Naturally, they went to Boston to secure jobs. This loss of local workmen made hard sledding for the other furniture company, Haley, Morse and Boyden. Within a few months, this firm also closed up. The war had crippled them badly. Thus, the town was left with only one industry of any size, the Winslow's tannery. So you see, it was a serious blow to the town. Its two chief industries were gone at the moment when the entire nation was flat and exhausted from the effects of the war. Only the profiteers were "in the money."

THE CARS COME TO TIOT

Originally published on April 30, 1935

On the morning of April 23, 1850, the first official train stopped at South Dedham Station (now Norwood Station on Railroad Avenue) on the Norfolk County Railroad, which was opened on that date.

Behind that simple statement is a tremendous story that would require a book to hold it. As far as Norwood itself is concerned, that date can be regarded as the dividing line between colonial Norwood and modern Norwood. The opening of our first railroad line was directly or indirectly responsible for almost everything that you, the reader, know as "Norwood." The laying of a network of similar lines all over New England in the same period marks the end of agriculture and the beginning of the domination of capitalism and industrialism, which have ruled this section with an iron hand ever since the railroads made modern industrialism possible.

You may not know what all this has to do with our first local railroad. Nothing—except as a slight background for the picture because the Norfolk County Railroad was, like all the others hereabouts, an industrial railroad first and a public passenger railroad second. This has been evident from the

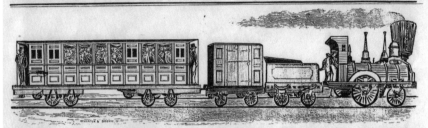

NORFOLK CO. RAIL ROAD.

FROM PROVIDENCE AND BOSTON STATION, BOSTON.

On and after **WEDNESDAY, May 16th,** the Cars will leave Blackstone and Boston as follows.

Leave Blackstone at 7.20 A. M., or on arrival of the Train from Uxbridge. **Returning, Leave Boston at 4.45 P. M.**

Stages from Medway, Medfield, Wrentham and Woonsocket, will run in connection.

Freight Trains leave Boston daily.

H. W. NELSON, *Sup't.*

May 14, 1849.

A poster advertising the first railroad service through South Dedham in 1849, now the MBTA Commuter Rail Franklin Line. *Courtesy of the Norwood Historical Society.*

beginning in the excellent and obsequious freight service it has offered—and its grudging, expensive and shortsighted passenger service. New England railroads' passenger rolling stock for local commuters has been the laughing stock of the nation for years, in sections where the public had the guts to demand and get modern cars and schedules. The New England public has humbly waited for Industry to get it decent passenger service. Industry, apparently, has only been interested in freight schedules and differentials. In the meantime, the buses and automobiles, in the freight and passenger business, have successfully completed a lateral pass, leaving the railroads moaning, "Why don't the public ride on *us?*" It remains to be seen if the railroads can regain the ball.

In the space at my disposal, it is impossible to tell more than the bare outlines of the beginning of "the cars." I call them that because it is the phrase that everyone used in the '50s when they spoke of the railroad. I do not know if this was a colloquialism, nor when "the train" was substituted for "the cars" in our speech.

Farms to Factories

The completion of the Boston & Worcester Railroad in 1832, to the north of South Dedham, of the Boston & Providence Railroad (via Canton) to the east and the Blackstone River Railroad to the west left a large triangular section of the state without railroad accommodation. The principal question among the hundreds of small industries in this section was how to bisect it in such a way as to secure the best railroad facilities. Nor do you need to be a historian to know that right here started a turbulent mess of politics, wire pulling, graft and personal animosities.

Here is a record of the first round of the fight, as written by the Honorable Luther Metcalf of Medway, who was a prominent figure in it:

> *The following statement was written March 8, 1872 from my recollections and memoranda in my possession: The first meeting of the citizens interested in the project of a Railroad from Woonsocket to Boston was held at Medway Village on Nov 30, 1836, among whom was Dr. Fowler, Willis Cook, and some other persons from Woonsocket, Artemus Brown, Luther Metcalf, Warren Lovering, Wyman Adams, and others of Medway, with other persons from some of the adjoining towns.*
>
> *After a free and pretty full expression of the views of those persons present, it appeared to be the desire of all to have a survey made from Woonsocket along the valley of the Peters River and Mine Brook through Bellingham and the northerly part of Franklin to Charles River, a little above Medway Village, thence to the valley of said river to Medfield and on easterly through West Dedham to the Dedham Branch of the Boston and Providence Railroad at the village of Dedham.*

Two engineers, R.S. Scott and S.B. Cushing, started the survey at once and got as far as West Dedham before the deep snow stopped them. Then, says the Honorable Metcalf:

> *The next year, in 1837, the financial affairs of the country were in such a disturbed state that little was thought of any new railroad schemes or anything else that required much outlay. Thus the matter remained until the autumn of 1844 when my mind was called to the numerous railroad charters that had been granted to the past session of the Legislature—I thought it a proper time to renew the old project.*

In short—somebody called it to his attention.

Messrs. Cushing and Scott finished their surveys on February 17, 1845. E.S. Chesborough Esq. surveyed the route from Walpole to Dedham. It was

found that the distance by way of Medfield, from Woonsocket to Dedham, was 25.85 miles and the estimated cost was $500,299; the route via Walpole was 28.38 miles and the estimated cost, $553,689.

And there you have your ring roped off for the fight! What a scrap it was! It is impossible to give the facts, and unnecessary. You are seeing it repeated, with all its essential details, in the efforts of the bus lines for franchises. This railroad fight centered on the legislative committee on Beacon Hill. Roughly, the procedure was for one man, or "petitioner," to head a group of businessmen who wanted a railroad. The proposed route was then by the name of this man. In the session of the legislature that began in January 1846, there were ten such tentative routes in this great industrial triangle, all fighting for charters.

After many and prolonged hearings before the committee, and much conference with each other, the committee reported in favor of the Norfolk County Route, with only one dissenting member who favored the (alternative) Perkins Route.

If the rejoicings were great with the old corporations and among the citizens of one tier of towns in Norfolk County over the success of their strenuous labors, the grief and disappointment among those who had originated the whole movement can hardly be described. There were charges of treachery to pledges and obligations, of weakness and want of tact and skill in the management of the case that embittered many minds and continued for years afterward.

The Norfolk County Railroad (NCRR) was opened for travel April 23, 1850. That year, another offshoot of the NCRR was incorporated, looking to an independent entrance into Boston, preparatory to their New York project called "the Midland Railroad," from the Norfolk County Road in South Dedham, to the foot of Summer Street in Boston. The corporators named were Messrs. Marshall P. Wilder, Dedham, Robert Codman, Welcome Farnum and H.K. Horton.

And so, let us leave the local industrialists shaking hands on that great day of April 23, 1850. Only doughty old Captain Moses Guild is glum. No dancing in the streets for him. His line of freight wagons, rumbling over the turnpike from Boston to Providence, had made him Norwood's richest man and largest landowner. Now the new railroad has washed him out of the picture. Many another man and business are to be either made or ruined by "the Cars."

NORWOOD'S FIRST PRINTING PRESS AND NORWOOD'S FIRST PRINTER

Originally published on October 15, 1935

If you should happen to be in Melbourne, Australia, and were bored to tears while waiting for your boat, what would be the correct thing to do? You could either go down to the bar and get acquainted with the city or send a bellhop out to buy a couple of new American novels. The chance is good that one of them would bear this imprint: "the Norwood Press, Norwood, Massachusetts. Printed in the United States of America." Or it might be "the Plimpton Press" with similar text. These familiar and heartening words might cheer the Norwoodites in any city on the globe.

But *the* first Norwood press—the great-great-granddaddy of all the big batteries of marvelous presses in Norwood, now roaring off hundreds of miles of paper each year—is still in existence [in 1935]. And it could, with a little oil and patience, still print a "visiting card," a program for a play in Village Hall or a billhead for Deacon Sam Morrill or Bigelow's Dry Goods Store. It stands, dust-covered and almost forgotten, on top of a cupboard

A bill from the pioneer Metcalf Press to Norwood resident Willard Dean for the printing of wedding invitations. *Courtesy of the Norwood Historical Society.*

in the office of the Metcalf Press, 152 Purchase Street, Boston, while its sprightly, white-haired, eighty-six-year-old owner, Mr. T.O. Metcalf, sits at his desk nearby. Sixty-four years ago last month, he and two other boys started the first print shop in Norwood with this pioneer Norwood press.

The story of Norwood's first printing business is important in its history. Not merely because T.O. Metcalf is the oldest alert and mentally active person in Norwood, and possibly in the United States. Certainly, he is the ancestor of the Massachusetts printers. Not because of the fact of his connection with the first job-printing business in a town that has become internationally famous for book printing. But because the way this little business started and grew is so typical of the way many other Norwood concerns started and grew to prosperity. It is worthwhile to try and paint the background and details of this commercial picture of the period when Norwood had just struck its stride toward the position it now occupies.

In 1852, George Harvey Metcalf, his wife and son, Thomas O., were living in Cumberland, Rhode Island, in which territory the city of Woonsocket is now located. Tom had been born three years previously, in 1849, and still remembers the roar of the Woonsocket Falls in his baby ears. Business was none too good with George Metcalf, and he asked Austin Saunders, who had married a relative of his and was living in South Dedham, if he couldn't get a job in that town. Since Austin was then working for a young fellow named Willard Everett, who had just bought out Jabez Boyden's cabinet shop and was starting out for himself, it was not hard for him to induce Deacon Willard to offer George Metcalf a job. By modern standards, it wasn't much of a job. The deacon asked George if he thought he could get by on six shillings a day. This equaled about $1.25 in present money. George thought it good pay and immediately moved his family to South Dedham. The Everett cabinet shop was then in the little frame building that was long the office and mill of the Morrill Ink Mill. A year or so after Mr. Metcalf arrived, the deacon built himself a new shop at the corner of what is now East Hoyle Street and Washington Street. But George Metcalf did not work there. The doctor told him he would have to get out of the dust of a busy cabinet shop. So he got himself a job as station agent at Winslow's Crossing Depot on the Norfolk County Railroad, which was struggling to remain a good concern and not a streak of bankrupt rust.

By this time, there was another boy in the Metcalf family, Albert by name. Tom and Albert grew up as active, husky lads, educated in the South Dedham grammar school. Tom graduated from the Everett School in 1867. He was good at "figgers" and had picked up knowledge of simple bookkeeping. But it goes without saying that both boys had gained a secondary education in

and around the railroad depot. Tom, especially, was his father's right-hand man and had learned the station agent business completely. By the time he was twenty years old, he was helping with the depot work and keeping three sets of books: one for Winslow Bros. tannery, one for John Morse, the teamster who was carting Bird's freight daily to Winslow's station and Boston, and one for his dad at the depot. He had firmly made up his mind to be a railroad man and had already pinch-hit as station master at Readville, Walpole and other important points up and down the line. In his off time, he was going to Boston two days a week and soliciting business for the Winslows along South Street. Printing was the last thing T.O. was thinking about.

But brother Albert and his chum Herbert N. Rhodes had bought, in Boston, a secondhand printing press for twenty-five dollars. It stood about two feet high, weighed seventy-five pounds and had a series of cogs on one side to move the bottom plate and a long handle, such as one sees in pictures of Benjamin Franklin at work, to make the impression. On it was a brass plate with these words engraved: "Sam'l Orcutt's 97 Patent, Boston, Mass." This was the maker's mark. The name of the firm that sold it is also on the press—"Moore & Co., Boston."

The logical place for Albert and Herbert to play with their new press and learn how to become printers was down at dad Metcalf's depot. The ticket office was a room walled mostly with glass. So here, Albert set up his little press and type case. Between trains, ticket and freight customers and other depot jobs, he and Herbert wrestled with the typesetter's "stick," "pied type," make-ready and sticky ink rollers. After they had both filled their lungs with the delicious odor of mixed molasses and printer's ink, which rollers always exhaled, the damage was done—the bug was inoculated. Albert and Herbert decided to go into the printing business in a big way. They moved out into the baggage room so as to have more space to throw their weight—and ink. Then came the eventful day when their youthful eyes fell upon the empty, abandoned store of Lemuel Dean, just across the way from the depot. They told Tom, who of course had been playing along with them in his spare time, that they were going to rent the old store, and why shouldn't he join the venture as business manager and bookkeeper? Tom said he guessed he would. And thus a potential Harriman or Vanderbilt was lost to the railroad world.

They moved the press over to Lem Dean's in September 1871, when Tom was twenty-two years old, and started the T.O. Metcalf job printing office. Albert was the compositor, Herbert was the pressman and Tom ran the office and solicited the business around town and in Boston.

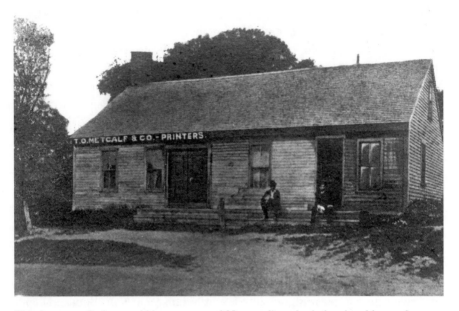

The tiny start of what would become one of Norwood's major industries, this was the home of T.O. Metcalf Press, in the former Lem Dean Market. *Photograph courtesy of the Norwood Historical Society.*

But, of course, the Sam Orcutt was limited in speed and production. And since Tom and the other boys were toiling early and late, the business was growing. South Dedham had become Norwood the year after the Metcalf Press opened. Norwood people found it more convenient to kick the hometown printer than the Boston firms to whom the business had been going. So the boys cast their eyes around for a larger press—and found one going full blast up on Nichols Street in the home of Charles Gilbert Wheelock, who lived next to Tyler Thayer. Wheelock was already an expert trained compositor, having learned his trade with the L.B. Wilder Company in Boston. He had bought a new horsepower Gordon Press, operated by foot power. On this "kicker" he was turning out more and better work than the Metcalf outfit. But he needed an organization as badly as the Metcalfs wanted a bigger press. So it was natural that Charlie Wheelock moved his Gordon down to the Lem Dean store building in 1873. After that, until June 1876, the jobs came out faster and more profitably, each one imprinted "T.O. Metcalf, Steam Mill, Norwood, Mass." This imprint was the ancestor of those mentioned in the first paragraph.

The Story of Peabody, the Gunmaker

Originally published on May 5, 1936, as "Silhouette of Old Tyot, No. 6"

Henry O. Peabody, who owned the King Gay Farm, which he gave to Norwood for an industrial school for girls, was one of the biggest ordnance shots in the country. He perfected the first breech-loading rifle to help save the Union and then ran smack into an arms lobby, which stole from him and his backers the fruits of his genius and their heavy investment. Here is one of those forgotten dramatic and romantic incidents of industry that shows why we glibly speak of a Remington rifle and look puzzled when one mentions a Peabody rifle.

In the Boston Public Library you will find a dull-looking book entitled *American Breech Loading Small Arms* by Charles B. Norton, brevet brigadier general, USV (New York: F.W. Christern, 1872). Turn to chapter three, page eighty-three. It is headed "The Peabody System." Here is revealed a lot of things that we wager no one in Norwood ever heard of. And some things that the Remington Arms Co. of Bridgeport, Connecticut, would, if a big corporation ever does give a darn about its past history, like to have forgotten.

Quoting General Norton:

> *The record of this arm* (the Peabody rifle) *entitles it to a front rank among the productions of American industry. The inventor, Henry O. Peabody of Boston, an active and thoughtful mechanic, had his attention first directed to the subject of breech loading arms at the commencement of the war* (Civil). *After careful labor and study, he worked out the original idea of the mechanism of the Peabody gun, which is today, as he made it, unimproved and unchanged, the first and only patent in the United States having been taken out July 22, 1862.*
>
> *Since its origin this arm has been manufactured and controlled by the Providence Tool Company of R.I., who have spared no expense in machinery and workmen to produce an arm complete and satisfactory in all its parts, and with a capacity to turn out 10,000 guns per month. The interests of this system have been represented in this country and Europe by Marshall F. Benton, Esq. of New York City, through whose kindness and attention the following facts have been obtained.*

The Civil War, with blue and gray armed with old-fashioned muzzleloading muskets, was roaring to its appointed finish. But no one knew that. They did

know that the length of time it took to load and fire a Springfield rifle, or a Rebel gun, had a definite effect on the winning or losing of battles. As General Norton has indicated, the idea of a breech-loading gun had been thought of by one lean, hard Yankee in Boston as early as 1862 and turned into a visible, shootin' reality. Other inventors were working desperately on the idea—in order to save the Union and make their fortunes.

In 1864, the United States Army Board issued a general invitation to any and all of these inventors to submit their guns at the Springfield Armory for examination and test. The army would select the gun it considered best and adopt it as the standard gun for all the troops in the field and on garrison duty.

On a day in January 1865, Henry O. Peabody and representatives of the Providence Tool Company appeared with their quick-firing baby at the old Springfield Armory. There they found sixty-four other breech-loading models awaiting the test! Yankee ingenuity had not been asleep! And remember this also: the Remington breech-loading rifle was one of the sixty-five guns.

Each of the sixty-five rifles was then submitted to every test and hardship that the army board could think of. They were fired under more drastic conditions than they would ever encounter on Southern battlefields. Firing speed was increased to beyond the maximum. Powder charges were stepped up in the same way. The board threw sand on the guns—mud, gravy. Then they threw water on them and put them outdoors on a bitter January night. In the morning, all guns were covered with a coating of ice. They were fired in this condition. So, from January until April 1865, these tests went grimly on—gun after gun being eliminated. Finally, they ended. "The Board who had witnessed these experiments recommended the Peabody gun for military service," writes General Norton. The seven officers of the board signed the report.

But on April 9, 1865, Lee surrendered his army to General Grant at Appomattox Court House, and the war ended. Henry Peabody had won his war, too. The desperate need being ended, "the government did not find it necessary to act at once on the report." Peabody's was a barren victory.

The next year, General A.B. Dyer, chief of ordnance, under the date of July 12, 1856, decided to wait and see if some of the rejected guns had not been improved. Do we faintly see, between the lines of this decision, a portly gentleman from the Remington Arms Company sitting over the whiskey and cigars in a private room of the Fifth Avenue Hotel, New York?

The army board had another trial at Springfield in March 1868, with the same tests as that of 1865. There were sixty rifles competing, including the

Remington. Again, "the credit for Supremacy was awarded to the Peabody arm by this Board," reports General Norton. But no order was ever received by Mr. Peabody from the U.S. government. The Remington Company was improving its gun—and its lobby.

Later, they had a third trial. General Norton's story includes a long, signed statement from the Providence Tool Company. Among other things, it states that this was a secret trial and that they, the Providence Tool Company, did not know it was being held and had no gun in it representing them. This statement is set in italic letters. (Remington got the contract for rifles for the naval service on August 2, 1869. Remington rifles were recommended for the army of the United States on June 10, 1870.)

So, Mr. Peabody and the Providence Tool Company had to turn their eyes to Europe. And here, the Peabody gun was received as a triumph of Yankee cunning. But Peabody wasn't smart enough to patent it in all European countries, the patent laws of that era not being what they are today, and Europe soon swiped away every good feature of the Peabody masterpiece and said "Thank you, Mr. Peabody." Until they did that, he cleaned up abroad. The Swiss government ordered fifteen thousand; Romania, twenty-five thousand; Cuba, Canada and Mexico, twenty-four thousand; and France, thirty-nine thousand. The Turkish government apparently opted it as their national arm.

While Remington could put it over Peabody in the United States, they couldn't do it in England. I see in a "Report of a Special Committee on Breech Loading Rifles, presented to both Houses of Parliament by Command of Her Majesty" in 1869, there were nine rifles that "went through the (British) competitive trials." The last two names on the list are "Peabody and Remington." But the rest of the voluminous report does not even condescend to mention those blooming upstart Yankee entrants! In the end, the British-made Martini-Henry breech-loading rifle was adopted for the British soldier by the Royal Arsenal at Woolwich on February 11, 1869 (page twenty-five of the report).

The Remington lobby in the state of Connecticut couldn't have been clicking so well in later years, for General Norton says that the Connecticut State Guard, after a long trial of guns, adopted the Peabody rifle. While Remingtons were being turned out in Bridgeport, Connecticut! About the same time, the commonwealth of Massachusetts came through with $50,000 to buy Peabodys for its state guard.

THE GEORGE WILLETT ERA

Originally published on September 8, 1936, as part of "5 Frontiers of Tyot"

Nineteen Hundred and Nine!

This was a pregnant date in Norwood's history. It was the beginning of an era that changed the town more than it had ever been changed before. And perhaps more than it will ever be changed again in the same length of time.

That careful, and as yet unappreciated, historian Mr. Charles E. Smith of the *Norwood Messenger* calls the turn on this fact in his admirable *Historical Sketch of Norwood for a quarter of a century, ending Dec. 31, 1920,* published in the elaborate souvenir edition of the paper as of that date. On page four, he wrote:

> *At the annual town meeting, March 1, 1909, it was voted on the motion of Marcus M. Alden "that the moderator appoint a committee of three who shall investigate the financial condition of the town and make a report thereon at a later meeting, with recommendations." Moderator Clifford B. Sanborn appointed as this committee George F. Willett, chairman, Hon. Frank A. Fales and Cornelius M. Callahan.*

This was Mr. Willett's first official appearance in town affairs.

On the same page, Mr. Smith wrote: "It was in 1909 that buildings began to be erected on the section then known as the Flats at the south end of the town." This was the beginning of the third frontier of Norwood, a frontier superimposed on its original frontier of Old Tyot.

Those of you who lived through the Willett era in Norwood must now realize that you saw the most dramatic period of our history; indeed, the most colorful series of events that ever befell any small town of New England. If Sinclair Lewis ever gets wise to the behind-the-scenes study of that plot known as "Norwood 1909–1920" he will write a story that will make "Main Street" look like a pale pink Sunday school tract. The writer had no part or profit of these years. He was not here. All he knows is from hearsay and reading the printed records. It is not my purpose, nor is there space, to treat this Willett era in any detail. Yet, if we are going to look at the frontiers of Norwood fairly, we certainly must touch upon the man and his friends who took the first two frontiers, Old Tyot and the Hook, and modernized them in a single decade.

One of Norwood's most historically significant citizens, George F. Willett, local industrialist, philanthropist and founder of the Norwood Civic Association. *Photograph courtesy of the Norwood Historical Society.*

The bare skeleton of the story is as follows: Before the turn of the century, Norwood never had a benefactor or philanthropist. In 1909, George Willett suddenly towered into the scene as a public benefactor. The old-line, rugged individualists who had built the Hook and thought they were going to keep right on doing so in the ancient hit-or-miss, catch-as-catch-can and devil-take-the-hindermost fashion were at first amused at his actions and notions, then ruffled and in the end, secretly or openly hostile. First, let us briefly record George Willett's history. Then we will return to this reaction of the influential men of the town.

George Willett was born in Walpole on August 7, 1870. He was a member of the class of 1891 of Boston University, where he more or less specialized in a subject then in its very infancy—industrial chemistry. This stood him in good stead in later years, when he put the Winslow Bros. & Smith tannery on the basis of scientific chemistry—this plant being one of the first in the country to take what was regarded as a radical and rather questionable step.

The following data the writer obtained from Mr. Willett himself last week. He answered the rather personal questions with his usual frankness and good nature. After the three companies merged, the new firm of Winslow Bros. & Smith Co. was valued at close to $1 million. Its annual earnings were about $300,000 or $400,000.

Mr. Willet estimates that at this period he was worth about $1 million, the estate increasing steadily until 1908, when his income was approximately $500,000 or $600,000 a year.

After he became a millionaire, Mr. Willett says he formed a policy. He made a will leaving $1 million to his family. "From then on, every dollar I made I set aside for public good."

After the Dedham verdict in the Willett-Sears case, which gave $12 million to these two businessmen, Mr. Willett estimates that his fortune was about $8 million. He made a new will after this verdict, increasing the family legacy and setting up an industrial school. The reversal of the $12 million verdict wiped out the $8 million, the will and the school. In the end, it left Mr. Willett as trustee of the Norwood Housing Co., now Norwood Estates Inc., and including the trusteeship of the Westover properties. The trustees of the Norwood Civic Association—representing the people of Norwood—are also large holders of Westover property.

So much for the financial rise and fall of George F. Willett. What about his work as a philanthropist and benefactor along civic lines in Norwood? Up to 1909, George Willett had been minding his knitting as a wool and leather man, taking no part and little interest in the town affairs. Projected into the

chairmanship of a committee to investigate the tax rate of $25.60 and to consider the possibilities of a revaluation of property, Mr. Willett began to study the town of Norwood as he had been studying and reorganizing the old-fashioned plants of the Winslows and Smiths. At a town meeting in June 1909, the original committee of three was increased to fifteen, with Mr. Willett still chairman. This committee was ready and willing to confer with the board of assessors and assist them as far as possible. The assessors took the matter entirely into their own hands and had no further dealings with the committee.

In the end, according to the report of the assessors as of January 31, 1910, the tax rate was reduced from $25.60 in 1908 to $8.50 in 1909. And who was the target for all the congratulations, as well as all the passed eggs and cabbages that resulted from this tremendous tax reduction? You've guessed it—George Willett, the new leader of an old town that was growing like a vigorous, rank, unchecked and untrimmed vine.

The situation in Norwood was no different than in dozens of flourishing old manufacturing towns in New England. They had grown without plan or vision. Each had been exploited by succeeding generations for the selfish financial advantages of families, groups and cliques. As has been said that Norwood had no philanthropists or benefactors. It had had "public-spirited men"—lots of 'em. But the formula of their public spirit broke down something like this: number one, me and my family and business, 75 percent; my friends, church, lodge, etc., 20 percent; the public, 5 percent.

For instance, the writer can remember only one, solitary thing when he was a boy of the '90s that had been given for the benefit of all the townspeople. It was called Winslow's Park—a bare, stiff, uninviting little park at the corner of Walpole and Chapel Streets with a cold, white flagpole in the middle. No one ever used it much—for the citizens rather had the idea it was for the use of the Winslows. And it did make a nice open spot in front of their estates. In the churches, there were memorial windows and organs galore, each with a neat tablet telling the name of the donor and for whom it was a landmark. But what of wide, broad-minded, generous public spirit such as George Willett brought to town? There was none. Under the Willett stimulus, Jim Berwick also showed himself as a good sport in Berwick Park.

Honorable Frank G. Allen gave the senior high school athletic field and the windows of the Memorial Chapel in the municipal building. Mrs. E.J. Shattuck presented that little gem of a park on Winter Street. The Days gave the burial chapel at Highland Cemetery, which is an architectural classic. These and other benefactors of various degrees followed in the footsteps of Willett. Nor am I forgetful of the vast amount of private charity that has

been and still is being poured out in Norwood—the work of the churches and other organizations. These are all noble benefactions. But I think history will say that Willett was the Moses who struck the rock.

What happened when the Norwood Civic Association and the Norwood Housing Association began to operate on a scale that amazed the town was the most natural thing in the world. Imagine a checkerboard with black and white squares. Then think of someone putting a course screen diagonally across the board, so that the wires of the screen crossed every square. The checkerboard was the old-line families, groups, gangs and businesses. The wire screen was Willett and the hundreds of people who rose up and called him and his money blessed. Every place where a Willett wire crossed a Hook square, there was friction—antagonism and wire-pulling against the current of the Willett influence. He was engaged in the herculean task of making an old town into a new town. The old powers were busy trying to carry out their many and manifold schemes to carry on just as their fathers had. Add to this the fact that Mr. Willett had so many irons in the fire of his good works (and his vast business in Norwood and elsewhere) that he was a difficult man to work with. Had he been less busy, he would have made fewer enemies.

But the wonder of it all is, to the writer, looking at it from this distance as a neutral observer, that the Willett crowd got as far as they did and accomplished as much as they did. Of course, without the half-million dollars that Mr. Willett poured into the civic plant and hospital alone, it never could have been done. But it took more than money to tear down the old Hook, widen old Washington Street, build new stores, move old ones, build Willett Pond, playgrounds, a host of other projects in the Civic Association and get a new charter from the legislature to do all this and much more. It required a lot of cooperation from all hands. A titanic achievement—and all honor to everyone who had a hand in it!

JUST PLAIN FOLKS

A stage is valueless unless there are people to act upon it. Win Everett devoted numerous columns to portraying the folks he knew and those before him who populated Tyot. In these selections, he takes us into the early school system, shares a hot summer day at the local swimming holes, remembers a primitive nineteenth-century sport and re-creates the heartwarming sentiment of an Irish immigrant as he reflects on the American life in his newfound Norwood home.

LEMUEL DEAN: THE FIRST MERCHANT IN TYOT VILLAGE

Originally published on December 3, 1935

Trolling down the corridor of time as it passed in Tyot between 1795 and 1880 is a small, wispy figure that is rapidly disappearing into the perspective of oblivion. Let us try to catch a hazy picture of him—Lem Dean, the first storekeeper in Norwood. Long ago, when his memory was fresh in minds of those who knew and dealt with him, someone should have written a clear close-up of what was one of the most picturesque characters who ever brightened the life of our village. Now it is too late. There are probably only half a dozen folks in town who remember Lem. And theirs is only the dim, childish memory of a rather scary little man, frowsy and ill smelling, trundling a small pushcart on the streets of South Dedham. Yet his memory is indelible in their minds because you couldn't forget the image of a little man, invariably dressed in a black Prince Albert

cut-a-way [*sic*] suit and a tall, black beaver hat, rolling a pushcart full of peanuts, skunk skins and cow manure along the streets, day after day. Such was Lem Dean as the sun of his life set toward its eighty-fifth year, which was the end.

We know that Lemuel Dean was born the son of John Dean IV on March 22, 1795. His grandfather, great-grandfather and great-great-grandfather were all named John Dean. Lem was brought into this world of trouble, sin and taxes in the old John Dean homestead at 190 Dean Street. We know he married Julia Ann Morse, who was born in 1819 and who died December 18, 1890, at the age of eighty-one. They had seven children: Charles (1832), Rene Bullard (1834), a second Charles (1837), Lyman (1841), Lewis Ellis (1844), Henry B. (1849) and an infant son.

At the age of twenty-nine, we find Lem as tax collector of South Dedham in 1824. I think that it was just about this time that he got the yen to go into the grocery business. Perhaps he came into some money at about this period, for when, in 1828, the tavern of Abel Everett was moved across Washington

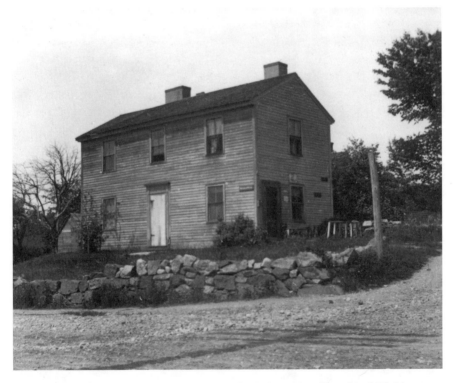

The home of Norwood's first storekeeper, Lem Dean, located at Chapel and Washington Streets. *Photograph courtesy of the Norwood Historical Society.*

Street to the northwest corner of Chapel Street, where its frame still stands, and the Congregational Church was erected on the old tavern site (replacing the odor of rum with the odor of sanctity), Lem Dean bought the tavern building and moved into it as his new home. According to Mrs. Marcia Winslow, who got her information from Jabez Sumner and Jarvis Fairbanks, both keen-minded old-timers and reliable as to their historical facts, Lem Dean started his grocery store, which was the first store in Norwood, in this house on the southwest corner of Chapel and old Washington Streets.

"Lem Dean's Store," which was probably opened about 1830, became a Tyot institution. Naturally, as the only store in town, it was the daily gathering place of our small citizenry. Here, and at the tavern down in the Hook, the gossip was swapped and manufactured. Here came the children on errands, with molasses or vinegar jug in hand, or the whale oil bottle. Here, according to Mrs. Winslow, "Lem traded in West India goods. That is, he kept on hand a hogshead of rum and one of gin, and one of molasses, and a few spices and a little sugar." The writer's aunt, Carrie Morse Hoyle, who lived as a little girl in "Happy Hollow" with her brothers and sisters in the John Edwin Morse homestead, used to tell, with many a chuckle, how she was sent to Lem Dean's for groceries and usually found the old yellow cat asleep in the brown sugar bin. And how Lem, invariably clad in his black Prince Albert and always wearing his black beaver tall hat, would slowly and ponderously wait on her. F.O. Winslow, in an address, remembered how the front of the store always carried a few skunk skins, drying in the sun while tacked to the clapboards. And how Lem could take longer than any living man to go into the cellar and draw a jug of molasses. Dr. Ralph Fogg remembers the interior of the store faintly. He says the counter ran right across the room lengthwise, giving a narrow passage between the floor and the front of the counter. Behind it, on the back wall, there were shelves carrying Lem's scanty stock of merchandise.

So, with one exception, we can think of Norwood's first store as little different from a multitude of other little country crossroads emporiums. The exception was the presence in Lem's life of Mephitis mephitica. According to all accounts and traditions, "Mephitis" was Lem's middle name. If your Latin is a bit rusty, I will remind you that it means "skunk." As long as I can remember, one couldn't mention Lem to any old-timer without the conversation turning in a trice to the odor of skunk around Lem Dean's store and the storekeeper's person. As the deer hunters say, he was always "high."

I guess, from a boy, Lem had hunted skunks for pleasure and profit. What a fox is to Sam Winslow, a skunk was to Lem. They were his avocation

and part of his vocation. He hunted them unceasingly, shot them in vast quantities and sold their skins whenever he could, up to his dying day. No one knows how much money he made off skunk pelts. But, for those times, it must have been considerable.

When Lem gave up his store, I do not exactly know. It existed, I am sure, well into the '60s. More dignified men had all come into the competition. People, including a few of Lem's best customers, began to seek sweeter-smelling trading posts down in the Hook. Eventually, as he grew older, Lem sold out.

Lem, despite his idiosyncrasies, was a thrifty and crafty man. He had made and saved money. When he sold out, he built a new house. It is still standing [in 1935] right opposite the office of the Whittemore Coal Company on Lenox Avenue. Here he passed his declining years, and here he and his wife both died.

I started this with a little figure marching down Time's corridor. I will close with the same figure, this time sketched for me by Mr. John Morse, son of John E. Morse, now of South Yarmouth but once a Norwood boy who knew and remembers Lem better than anyone else I have talked to.

Lem Dean was a little bit of a man. He was thin in his old age, when I saw him, but he might have been quite stocky when he was younger. His face was round and rosy and he had little, squinty eyes which reminded you of a pig. When he spoke, he always puckered them up. His voice was high and piping.

One of his oddities was that he invariably, winter and summer, wore a tight, black Prince Albert suit, with tails, and a high hat made of black— like the typical tall kelly of Uncle Sam, but smaller. His shirt was usually white, or I might say, had been white. And he wore a bow tie with ends which draped down artistically.

In my boyhood the sight of Lem Dean starting his daily trip to East Walpole down Washington street past our house was a common one. He had a green push cart usually, although sometimes he used a large wheelbarrow. When he started out on a selling and collection campaign, this cart would be fairly full of peanuts. And he would pass me, for instance, he would pucker up his eyes and yell in that high, squeaky voice, "Little boy! Want some peanuts?" It always went up on the "nuts."

I never bought any. And it wasn't because I did not have the penny. If you watched Lem toddle down the street, you would see his eyes were on the ground. Pretty soon he would come to a place in the road where an ox or a cow had visibly passed. Lem would stop his cart, take a little shovel which

was strapped on its side, and carefully transfer the souvenir of the ox into a hole which he had dug among the peanuts on one side of the load. Thus he would wander along collecting until he came to the house of someone whom he knew shot skunks. Here he would, perhaps, buy a skin or two of freshly killed skunk, and add these to the collection in his cart. So, if he had a lucky day and sold all his peanuts, which, I suppose, he figured were just as good as cellophane-wrapped by their shells, he would return past our house late in the afternoon with a nice load of skunk skins and manure. I suppose he used the latter in his garden. But he might have needed it for tanning the skins.

"Yes," said the descendant of Ezra Morse, the original settler of Norwood, "there was only one Lem Dean—thank goodness! But he was a gentle, harmless soul. And gave us many a much-needed laugh."

TIOT'S LITTLE LOST SCHOOL

Originally published on January 8, 1935

Just to mention an old schoolhouse, particularly in a country town, is like moving a magnet under a paper of loose pins.

Maybe it is because the schoolhouse is the first place where the average child feels the premier flick of the lash of the law—this, plus old associations, friendships, hates and scrapes. So when someone mentioned "Abbie White's Primary School" at the northeast corner of Railroad Avenue and Washington Street, the writer pricked up his ancient ears. He had not realized a public school was there from September 1873 until July 1878. As I gathered the following few facts with considerable difficulty, it came to me that this is one of Norwood's early schools that is rapidly being forgotten. So, let us peg down as much of its history as possible.

The long, angular and ungainly building, pictured herewith from a valuable photograph owned by Miss Clara Capen of Vernon Street, was probably erected as shown in 1856. I have not been able to find out who owned it first. Alfred Atwood's guess is that it was one of the Rhoades family, as their land bounds it on the north and east. He has a deed showing that a Willard Battelle of Taunton, Massachusetts, and his wife, Lavinia, sold the property to Alfred's uncle, Ebenezer Fisher Talbot, in 1870 and that he held it until 1877, when it was sold to George B. Talbot. It is also safe to guess that Tyler Thayer was the master builder who erected it. For three-quarters of a

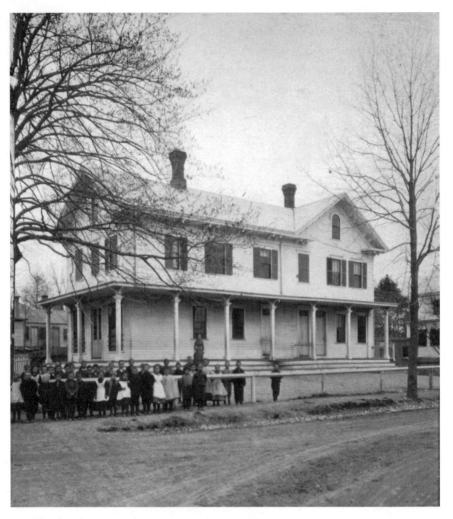

Abbie White's Primary School, located at Railroad Avenue and Washington Street, was in operation from 1873 through 1878 and was torn down in 1929 to make way for a gas station. *Photograph courtesy of the Norwood Historical Society.*

century, the building had a variegated career, being razed in 1929 to make way for a more sightly Standard Oil gas station.

In the fall of 1873, the lower front floor, the part with the piazza around it, was rented to the new Town of Norwood by E.F. Talbot for a primary school. The town found that the Balch and Everett Schools, which it inherited from Dedham, could only take care of the primary grades in the south and center sections. The rapidly growing sections on North Washington and Nahatan Streets, and on Railroad Avenue, had to have a primary school.

Hence, Mr. Talbot got a tenant and Miss Abbie A. White a teaching job. She was transferred from the Everett School. Later, the new North School on Railroad Avenue relieved the situation, and Mr. Talbot lost a tenant. Miss White became Mrs. Edgar Bigelow on December 19, 1878, and Miss Lucy Guy had taken her place. The school was abolished in July 1878, so Miss Guy was also out of luck. She taught in this school for twenty weeks.

They set up Abbie White's school in the fall of 1873. It cost $569.78 to run it for the school year. Paid:

Abbie W. White for teaching: $304.50
W.G. Shattuck for furniture: $115.20
C.W. Hartshorn for coal: $10.50
Willard Gay for wood: $3.00
George W. Gay for cutting wood: $1.50
Tyler Thayer for fitting up school: $75.78
James Engles for stoves and labor: $59.30
Total: $569.78

The next year, 1874, they raised Abbie to a $420 salary and paid E.F. Talbot $100 for rent. Later, they paid him $150. There was no rent itemized in the '73 expenses. All these figures are from the town reports. There are no books charged because the kids furnished their own; also, slates and pencils.

Somewhere, perhaps, there is a relic—a "silver service" consisting, mayhap, of a tea or coffee pot with cream pitcher and sugar bowl. Abbie White became engaged to Edgar Bigelow, son of L.W. Bigelow, the dry goods merchant, and quit her job about Thanksgiving time in 1877 to get married. Her last day at her teacher's desk was a sad one for her and many small urchins of both sexes. But the latter rose to the occasion nobly in a "surprise party to teacher." The affair was arranged by Carrie Shapleigh, who stood up on her desk after Abbie had tearfully rang the bell for the last time and said goodbye to her children. Miss Shapleigh had a large bundle, which she had been concealing in her desk all afternoon with great difficulty (plus the gracious oversight of Abbie, no doubt). Advancing to the rostrum, with her package, she made a speech of farewell and handed Abbie the silver service. Then there was much eating of homemade cake and sandwiches and great giggling over how surprised "Teacher" had been.

One day, when our Selectman Eugene Murphy was managing the gas station at the corner of Washington Street and Railroad Avenue, he was sitting at his desk at a spot that was almost exactly the same as the site of his desk, fifty years before, from which he had thrown spitballs in Abbie White's

school. An automobile drove up and 'Gene went out to service it. He noticed a West Virginia number plate on it. As the driver paid him, he remarked, "I went to school at this spot just about fifty years ago. What do you know about that?"

'Gene squinted at him carefully and remarked dryly, "I know plenty about that, Walter Ellis. For I, too, went to school at this spot fifty years ago. And you were in my class!"

As I was saying—you only have to mention an old school building.

JOHN KILEY: TIOT'S FIRST PRO

Originally published on August 28, 1934

Not long ago, before the American boy went airplane, the he-boy dreamed that someday he would boss the cab of the Empire State express train. When his parents pooh-poohed this silly idea, he made his grammar school ball team, made the high school team, made his freshman team in college, made the varsity and then made the winning run in his commencement week game and made his father and mother almost mad with joy. Then he got a job in an office.

Johnny Kiley reversed this great American tradition. In the summer of 1876, he made the Norwood baseball team as right fielder and "change" pitcher. His parents kicked like the dickens. The next summer he went with the Hyde Park team, and his folks were all against it. By 1882, he had built a reputation as a player, which won him a position as shortstop with the Washington, D.C., Nationals.

And his people were disgusted. He came back home and played with the Lynn team in the old New England league, in that day one of the most brilliant and talked-of teams in the country. The Kileys could see nothing in such foolishness. They felt the same when Johnny played with the Boston Nationals. At last they put their feet down and said, "Johnny! Get yourself a man's job in Norwood!"

So Johnny, being an obedient boy with many a sad backward look at the green diamond he could have conquered, got a job at our car shops taking locomotives to pieces to see what made them tick. One day, a chunk of cast iron fell and cut a five-inch gash in his head and fractured his skull. Seven weeks in bed followed. He hovered between life and death. Then, Dr. Lew Plimpton, who had been a ballplayer himself and thrilled to see Johnny play, said to him gently, "Your ballplaying days are all over, Johnny."

"Why so, doctor?" asked Johnny, who was feeling pretty chipper in his little white bed.

"When you start to play," answered Dr. Plimpton, "you'll see a dozen balls where there ought to be one. You have injured an optic nerve."

And so it proved, Johnny Kiley, Norwood's first professional athlete, was all through. He became John F. Kiley, for many years town clerk of Norwood, a popular merchant of shoes and now, in his seventies, a machinist living in his charming home at 14 George Street.

Such is a thumbnail sketch of Johnny Kiley. I interviewed Mr. Kiley the other evening and found him to be a gallant, courteous gentleman of the old school—a good sport in the finest sense of the word. And from him I got a background of local baseball history, which I wish I had gotten earlier.

Mr. Kiley noted:

The years between 1869 and '73 were indeed the formative period of baseball in Norwood and the country over. But what is hard for you young fellows to understand is the way the older people in those days ignored all such games. They were just "boy's games," a noisy mysterious thing the kids did after school. Or some men playing a game on which they are probably BETTING! There was not the slightest respect for or interest in sport or baseball as we understand it today among the adult population. Men and women worked ten or more hours a day. They took no vacations and few days off.

For some years before 1869 boys and men played "round ball," sometimes called Massachusetts Ball or "plug ball." Three posts six feet high and three feet in the ground were set up in a big triangle. The team was scattered in the field and one man pitched to a batter who used a flat bat much like a cricket bat. He could hit the ball in any direction front to back or side. The one who caught or got it could throw or "plug" it at the running batter who made for one of the posts and swung himself around if he got there before being hit. If hit, he was out. He made the next post on the next hit and so on, home. A simple, rough tough game I assure you.

I was a kid about eight when the first baseball game was played in Norwood, probably around 1868. It happened like this: A group of South Dedham men somehow learned to play a new game called "baseball." They invited another group from West Dedham (Westwood) to come over and learn it. They did so—and this initial game of instruction was the first game of baseball ever played in this town. I was only a little shaver, and I remember the names of all the Norwood men who took part in this historic game.

SWIMMIN' HOLES OF TIOT

Originally published on June 4, 1935

Lilacs, fat robins in the pink-blushing apple trees, skunk cabbages, the smell of black-alder thickets, paths through the ferns beneath the pines—and the "Swimmin' Hole"! It opened with an official splash about June 1.

Tiot of the '80s and '90s—"the Place Surrounded by Waters"—did not lack these little paradises, where much of the boy-history of those days was written. But parents, fearful lest Johnnie get drowned, did not realize that. What a wonderful, exquisite world of pleasure and thrills those good little boys missed who never came home at night with suspiciously wet hair and rumpled shirt! Now that world has vanished. The swimming holes are all gone. "Supervised play" and bathhouses at five cents have taken the place of naked freedom, 100 percent sunbaths and the survival of the fittest. But the demands of industry, civic improvement and increased population can never take away the memory of the swimming holes from those lucky lads who once strained the gold of pleasure from them.

Norwood's swimming holes were a gang matter. Nothing unpleasant. Nothing cut and dried. (Unless you consider the bathers, who dried with their shirts.) Just a sort of unwritten law, like that mysterious code of boyhood, which baffles the elders, yet works silently and efficiently from generation to generation. The swimmin' hole code of Norwood is a dead letter now. For nothing is left except the crowded Willett's Pond, the new municipal pool in Hawes Brook and the Neponset River hole—poor, pale substitutes for the old holes!

Girls didn't swim in the swimming-hole days. It seems strange to think of that today. But swimming was a boy's sport. The complete absence of bathing suits at the holes was one good reason for this. The other reason was the ten or fifteen pounds of bathing suit in which Madame Grundy swathed a nice girl when she swam, or attempted to. There was real and bitter pathos in the verse "Mother, may I go out to swim?" and, pinned on a boy, it was a stark tragedy.

Boys of one neighborhood, a natural gang, usually played the same swimming hole or holes year after year. It got to be a habit. If another crowd tried out these holes, it was all right. They were public places. But by an invisible, intangible telegraphy, the regulars made the visitors understand that they could probably have a better time at their own holes. Which was perfectly true. They could. This was a naturally supervised recreation. And since there were not so many boys then as now, the plan worked beautifully.

Ellis Pond, a popular nineteenth- and early twentieth-century swimming hole, offered a cool respite on a hot summer day. *Photograph courtesy of the Norwood Historical Society.*

There were enough holes to go around. Another unwritten law was the use of the holes by the older boys and men after work. The kids just didn't swim then. Once in a while there would be a clash. Some swell fights have been pulled off at the holes. But that could also be said about the schoolyards.

"Purgatory" and "Guild's" were the perfect holes—the sort that Tom Bailey Aldrich and Mark Twain have made immortal. They were small kingdoms, isolated, far away from the village and any trace of parental supervision. Both were at least a couple of miles from most homes. But did boys of that age think anything of walking a couple of miles to swim and a couple back to eat? They never gave it a thought. The walk, in fact, was part of the fun. The writer remembers the summer he learned to swim in Guild's Pond, which was just below the dam of present Willett's Pond. He walked up there from Winter Street every morning and every afternoon for the best part of June, July and August. And ditto for several succeeding summers, although by then we had moved our base of operations from Guild's to the Ellis Pond dam.

Incidentally, that first summer when I was dog paddling on a board around Guild's, my dear mother thought I was building huts up back of Chickering's pasture. She nearly fainted when, the next summer, we went down to Southport, Maine, and I absentmindedly dived off the dock with the rest of the men. Breaking the news to the folks that one could swim was, in those times, much like that adult problem of telling Willie there isn't any Santa Claus. What a lot of fun swimming tanks and Boy Scouts have taken out of life! I can only say, "Boys, never disobey your parents."

Purgatory Pool is all dried up and drained now by the Norwood waterworks. Harry Gay tells me there is a garden now where Purgatory used to sparkle, a bright little jewel of water, far down in the thick woods at the foot of the hill in Purgatory Swamp. Sometimes it was called "the Lily Pond" for it was the only pond in Norwood that grew white water lilies. In season, it was started with their magnificent pink and white loveliness. Around it was a soft, grassy meadow. This was big enough to play ball upon, and many a good game of scrub has been enjoyed at Purgatory. There was no springboard or dock, just a muddy bank and deep hole to dive into.

The "Cock" Robbin's swimming pool, fed by a brook from "Snake-Up" Pond, was originally the supply pond for a little tannery that stood, in 1851, back from old Washington Street in the hollow below the hill, about where the South End Hardware Store is now located [in 1935]. In the 1800s, Mr. Robbins built, on the tannery site, a typically mid-Victorian mansion, now owned by Mr. Abdallah, with a ballroom upstairs and a private bowling alley in the basement. The yard was, of course, dotted with marble statues of coy Venuses and Minervas, with the inevitable fountain in the middle. This fountain was far from the old tannery water supply and was thought well of by Mr. Robbins, who was naturally called "Cock." He was engaged in the leather and real estate business in Boston. His son, Charles, built the house now owned by Henry Crosby on Walpole Street, the same house that became a canoe factory.

Going down to the very bottom of the scale, we enter the Car Shop swimming hole. "Hole" was the perfect title. It was filled with water that drained from the shop junk piles above. The bottom was black, sticky mud, and this was full of driving wheels, seat springs and broken glass. Its surface was covered with gobs of black grease. Yet our gang, forbidden for some reason to go to Guild's or Ellis, and driven to desperation, went in this pond one afternoon. Enough was enough. Henceforth, we just salvaged junk when we went down there, or played in the abandoned passenger car on the junk pile.

HAVE A DRINK OF DEACON TINKER'S "CHOKLIT SODY"!

Originally published on September 18, 1931

Sooner or later, the "old shacks" in the backyard of the municipal building will be replaced by something better. It may be a post office; it may be new business blocks. At all events, there is one of these humble, dingy little buildings that deserves a valedictory—a swan song far better than this writer can sing. I refer to what was once the Tinker Building, now occupied on its ground floor by a smoke shop and a men's shop. If any old-timer wants to chip in any additions or corrections, they will be gratefully received by the writer.

There is probably no one living in Norwood today who remembers when the Tinker Building, with its three stories and mansard roof of slate, was erected in the most commanding position in the village. The writer

Francis Tinker's Drugstore, headquarters for "choklit sodys," was located in the center of South Dedham's downtown district, known as "the Hook." *Photograph courtesy of the Norwood Historical Society.*

has a photograph, and there is one in the library's collection of historical photographs, that shows Village Hall from the steeple of the Universalist church. In the foreground is the site on which Tinker's Block was later built.

You readers who lived in the lovely quiet village that was the Norwood of 1880 to 1900, with its Washington Street running sweetly beneath a very cathedral of towering green elms and maples from the first high bridge to Winslow's station, will smile at this minute location of Tinker's Drug Store and what was then the municipal building of the town. Every old town has some focal point that draws fond memory like a magnet.

It seems to me that Tinker's and the old Village Hall building are Norwood's. I do not suppose there are two buildings still standing that bring a little smile to the lips and a wistful look in the eyes like the mention of these two old landmarks to those who knew Norwood before it was jazzed up and improved.

There was never anything beautiful about Tinker's Drug Store or the building housing it. It was, in fact, about as hideous an example of early Victorian business architecture as one can imagine. Tinker's Drug Store occupied the entire lower front of the building. Just a dim, none-too-clean, delightfully scented, old-fashioned drugstore. A wide, roofless platform extended the whole front width of the building, shaded by the last of the old apple trees. One entered the store by dragging one's short legs up two high steps and across the porch.

Do you remember toiling up those steps with a big, hardly won nickel in your hand to buy a "sody"?

Do you recollect the little squat, grimy marble fountain at your left as you entered? And behind it dear, kindly, gentle-voiced Deacon Tinker with the black skullcap on his pure white locks?

And then the deacon said slowly and softly, "What will you have today, little boy?" Gosh! A momentous question! Your eyes wandered over the round silver disk labels—"Vanilla, Strawberry, Lemon"—about six flavors in all, as I remember. A gentle trickle of saliva wet your lips. You stood on one foot and scratched your leg with the other in the agony of deliberation. And then you muttered, "Choklit!"

The deacon's "choklit" was ambrosia then. Actually, it was pretty wishy-washy stuff. Norwood never drank good chocolate soda until Perley Thompson opened a competing store across the Market Street from the deacon and introduced a chocolate "sody" that *was* a chocolate "sody"! It is still one of Norwood's mysteries.

While the good deacon puttered and poured and fizzed and squirted, the delectable odor of "choklit" filled the air and mixed with the savory scent

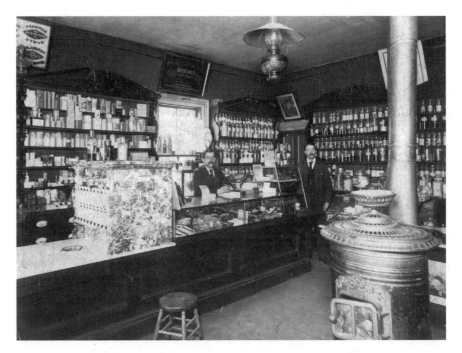

Inside a local business believed to be Francis Tinker's Drugstore. Note the "sody" counter at left. *Photograph courtesy of the Norwood Historical Society.*

of orris root, liquerish [*sic*] (root and black), checkerberry and wintergreen lozenges, peppermint stick candy, Lady Jane Grey perfumery or Hood's Cashmere Bouquet soap, alcohol, "Marguerite" cigars or what haven't you.

Your eyes read fearsome signs: "Don't Smoke Tobacco and Spit Your Life Away!" "Lydia Pinkham Saves Women!" "Rub Your Shins With St. Jacob's Oil."

Bottle, bottles everywhere! And not a darn label can you translate. Latin! You'll read those labels after you learn Latin at the high school in the abandoned Orthodox Sunday schoolhouse, where the gravestone maker now lives on South Washington Street, or in the little red building on what was later the Guild School front lawn and which later became Tom Mull's livery office on Town Square.

"Here's your sody, little boy." The deacon's low voice brings us out of a mellow trance with a start. Aye, there it is—a great bulbous glass set in a heavy silver holder with bubbling deliciousness pouring down on the marble counter. "Ice cream sody, of course," you say. Pshaw! No! Just plain soda. Good heavens! Ice cream "sody" cost ten cents! And the deacon didn't encourage its sale because it was a bother carrying a tub of ice cream. If

you must have ice cream and were a Bohemian in taste, go across the street to the Ice Cream Saloon. But decent people made their ice cream at home on Sundays.

As the "choklit" trickled downward, a mystic, churchy light filtered over one's small figure through the big red and green glass vases in the window, without which no mid-Victorian druggist could seemingly work his magic. It was also reflected on the pans of the bright scales balanced beside the candy counter. Tinker's candy!

AN IRISHMAN LOOKS AT LIBERTY

Original publication date unknown

When Mr. Raymond G. Pendergast of 74 Railroad Avenue recently presented the Norwood Historical Society, of which he is a member, with a magnificent framed copy of the Declaration of Independence, he perhaps did not realize he was also presenting the writer with a "Tale of Tiot." May I join my "thank you" with that of the society?

The story of his document of liberty really starts in a place and at a time where there was little or no liberty. The County of Waterford, Ireland, during the years from 1845 to 1850, was a sad spot. I am not familiar enough with Irish history to say they were "hanging men and women for the wearing of the green" at that time. But I do know it was the period of the great potato famine. People were dying of hunger, and the life of the whole country was being crushed and brutalized by the English system of absentee landlordism.

Anyway, James Pendergast, great-grandfather of Raymond, a husky young chap in his twenties, and his rosy-cheeked wife, both got fed up on Ireland in or about 1851. They sailed away from County Waterford for the great, legendary land of free America in company with many other families who felt the same way. Mrs. Pendergast was carrying a baby in her arms—Patrick Pendergast, born in Ireland in 1851 and destined to be the father of our James E. Pendergast, town clerk and accountant.

The little family landed in Boston and settled in the great Irish colony of that day in South Boson. In a few years, James Pendergast, with the memory of the green fields and bright streams of old County Waterford still in mind, began to hanker for the country. He moved to the hamlet of South Dedham. But the story of the copy of the Declaration begins in South Boston. It is the Pendergast family tradition that it is about the first thing "Jimmy," as he was called all his life, bought with the first money he earned.

Now the Pendergasts are not, on the surface, inclined to be sentimental about how and why Jimmy bought the framed copy of the famous old paper. "Maybe he bought it of some fellow at a bargain," say his daughters, Miss Catherine and Miss Mary, now living in their cozy home at 81 Railroad Avenue. "Or maybe he got it at a hock shop. Maybe he just thought it was pretty." But the writer is just sentimental enough to advance the idea that it was natural for Jimmy, coming from the virtual slavery of Waterford and Ireland, which was one of the last strongholds of feudalism in Europe, to want to see and own the actual printed guarantee that all men should be born free and equal in America. So he brought that big framed document to his little home in South Boston and hung it proudly on the wall—the only picture in the house and the only one the family owned for many years.

When the Pendergasts moved to South Dedham in the early 1850s, they took rooms in what was called "the Steam Mill," which stood where the bandstand now is situated at the corner of Washington and Guild Streets.

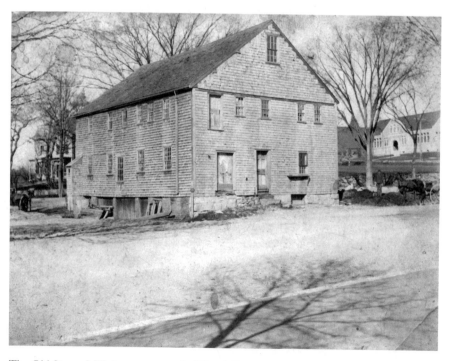

The Old Steam Mill, home to several of South Dedham's first Irish immigrant families, including the Pendergasts, served many purposes in early Norwood. *Photograph courtesy of the Norwood Historical Society.*

In the small living room of this Steam Mill home, the Declaration hung alone in its glory. According to Miss Catherine Pendergast, it always hung over the cradle in this house and in later residences. Under the august and stately steel-engraved letters and phrases of the Declaration, eleven babies were born and cradled. Eight of them grew up to be well-known and useful citizens of Norwood.

I doubt if there is another family in the United States that literally grew up under the Declaration of Independence. "And the miracle of it is," explains Miss Mary Pendergast, "that in all those years, that big piece of glass and paper hanging on the wall was never injured in the slightest by all that uproarious, sky-larking gang of kids. It must have been fated that we were to give it to Ray to give to the Historical Society."

NORWOOD'S FIRST HORSELESS CARRIAGE

Originally published on September 22, 1936

Someday the question will arise: "Who was the first automobile owner in Norwood—and when?" Here is the answer, copied exactly from a yellow brittle newspaper clipping found in the inexhaustible story of Day House records. The Gay Nineties journalist (for here was no garden-variety reporter who penned this story!) did not intend it to be funny. But funny it is at this distance. Yet it does seriously contain some nice historical touches of the times and the people in them. For instance—the old depot eyesores of Norwood, the architectural ideas of the period, the description of that wonderful new material "Portland cement" and the number of carriages and amount of harness a rich man had to strut in them [*sic*] days. Now, read what that modest violet Mr. George H. Morrill Jr. poured into the obsequious and flapping ear of the journalist:

Norwood Expecting a Gasoline Carriage. G.H. Morrill, Jr., Has Ordered It.

Norwood, April 14, 1896—Sometime next month the first horseless carriage in the region will probably make its appearance at the residence of Mr. G.H. Morrill, Jr.

The carriage is ordered and expected in a few weeks. It will be run by power generated from gasoline and will add one more feature to the already attractive country home of its owner.

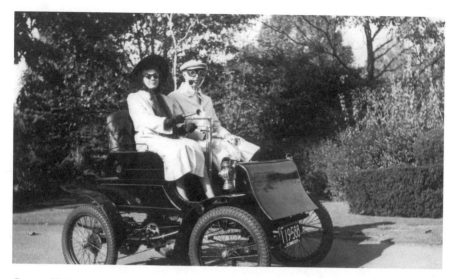

George H. Morrill Jr., his wife and Norwood's first "horseless carriage," circa 1896, set a new level for Norwood society of the era. *Photograph courtesy of the Hanson and Donohue Collection.*

There is a spirited rivalry within this pretty little town among the very wealthy residents of the place in the matter of residential seats.

Norwood boasts of many handsome and well-kept homes for the well-to-do; a boasting or a realization not apparent from the car window as one rushes through the town or slowly pulls up before either of the magnificent little stations with which the side of the railroad is dotted three or four times in the town length.

Those little stations, or two of them, at least, are objects of pity and contempt, and are causing lots of worry and trouble in an otherwise peaceful community. On the hill, among those handsome residences, is the costly country house of G.H. Morrill, Jr., one of the proprietors of the G.H. Morrill & Co. ink making concern.

Mr. Morrill was burned out of house and home in another location some years ago and straightaway laid the foundation and formed the plans for the present home.

Standing on a prominence, higher than any other in the country round about, in the center of a beautiful velvety lawn, surrounded by seven acres of the same grassy carpet like a vast Wilton of emerald hue—is Mr. Morrill's castle, built to please Mrs. Morrill and himself, with no others in consultation.

The house is built of fieldstone, every one of 12,000 perch was taken from the land on which the house was built and that surrounding it.

The architecture is of the old Holland style and is strikingly picturesque and artistic as well, both inside and outside. It contains 23 rooms, 10 of which are bedrooms, notwithstanding there are only three in Mr. Morrill's family, yet this big house is not too big, for Mr. Morrill entertains many friends at his house and his hospitality knows no bounds, as the Boston club and certain members of the A.H.A. can testify.

The driveways and the approaches to the house and the walks around it are made of Portland cement laid in large squares, and looks very much like white marble.

Before using cement for the driveways he sent a man to St. Paul to see the driveways there made of the same material, and to see what effect the frost had on this kind of ground-work. The report was favorable, and Mr. Morrill has a driveway and system of walks on his premises which cost in the neighborhood of $5000 to put there.

The portico is one of the features of the comfort of the house, and was the particular creation of Mr. Morrill, founded on an idea of summer luxury that bespoke familiarity with a foreign people which lived only for pleasure.

Twenty-eight feet wide and extending almost around the house, the piazza is lighted with three hall-lamps and is used in warm weather as a living room. Screened from prying eyes the family eat there and congregate there to read, to entertain or to do most things other people do within a stuffy room.

"The Pines," as Mr. Morrill calls the house, named from the piney woods that surrounds it and keep the air laden with a health-giving odor, cost in itself near $30,000.

The Winslows and the Plymptons started the costly house building business. First, one would build a house, a magnificent house, the natives would say, then the second would build a house putting the first in the shade and then Mr. Morrill started in on his, keeping the cost and many of the details in the dark, so much so that Mr. Morrill's father does not know how much his son's house and outbuildings cost.

Mr. Morrill, Jr., kept the neighbors guessing and now, after the symphony of a house is created, they are still guessing, but Mr. Shattuck, Mr. Morrill's brother-in-law, is building what he calls a little better house, and so it goes on to eternity. The rule will be the survival of the fittest and the Morrills are millionaires.

The stable at the Pines is not the least of the splendid estate. It cost $15,000 and is a marvel of simplicity and beauty as far as stables go.

Like the house, it is built of fieldstone and designed in the style of the Hollands in the 18th century. It is 108 ft. long and the street floor is divided into a carriage house, a washroom and a stable.

It is finished in spruce, natural, with a coating of shellac. The floors are made of Portland cement. It is lighted by gas, which, by the way, is made by the Morrills at their ink factory and furnished to the town: the gas is lighted by an electrics arrangement. No matches are allowed in the stable.

The carriage room contains a spider-phaeton, a cabriolet, a coupe, a brake, several Goddards and other carriages. New vehicles are expected in a few days for use during the summer. The harness case is 15 ft. long and is glass enclosed. Within are a dozen or more harnesses, and among them is a double silver mounted, imported harness which cost $300.

In the stable are a polo pony for Mr. Morrill's son to ride, several thoroughbred horses and some work horses. Mr. Morrill contemplates purchasing a pair which will make Mars turn green with envy.

Patent arrangements are numerous for cleanliness and facilitating the work of taking care of the stable, and what is within it.

The basement is provided with traps and drains, also in the interest of cleanliness.

Mr. Morrill built a $3000 house for the groom, Alec, which many people in the little town would be glad to live in had they the luck. This house is situated a minute's walk from the stable and is connected with the house and stable by telephone.

Mr. Morrill will leave his handsome home to go to London with the Ancients in June. Mrs. Morrill will go with him and they have planned to have a good time.

In the meantime, the building rivalry in Norwood will go apace and the townspeople will reap the benefits thereof.

THE DARK SIDE

Beginning with its earliest days, Win Everett's beloved Tyot was not without its share of tragedy and violence. In the following columns, Win covers some scary events and happenings in our town involving highwaymen, murder, accidents and an exciting escape of a wild steer that kept the town on guard for days.

THE GHOST OF A TIOT TAVERN

Originally published on October 30, 1934

All summer long I have been haunted by the ghost of a little seventeenth-century building—Norwood's pioneer tavern, which stood, between 1687 and the Revolution, on what is now the Morrill Ink Mill property. Not only have I been repeatedly visited by the dim specter of this building, which has almost been forgotten by men, but I have also diligently pursued it until I can now set down for you, with a good deal of pleasure, a few facts that may help posterity to recall "Henry White's Tavern in Tiot."

During its long life, White's Tavern was the only competitor of the Congregational church as a social gathering place for our little farming community. It was near the center of population, because the Norwood of that day lay in what is the south and central part of our present-day town. The town grew toward the north from what is now South Norwood. Moreover, White's Tavern (sometimes spelled Wight or Wyght) was an established inn on the Boston–Bristol post road, which was the first thru highway surveyed between two important centers in America. As such, it saw plenty of action.

It was situated on what was known as "the old Arch lot" and was on the right-hand side of Pleasant Street going toward East Walpole, opposite the present mill engine room.

We know White's existed as a post road inn as early as 1688. In the records of the Colonial Society of Massachusetts, there is "an accomtt of expences of a journey from Boston to New Yorke" under the date of 1688. "Att Fisher's" (which was the famous tavern in Dedham center kept by Lieutenant Joshua Fisher from 1658 to 1730), the traveler spent nine pence. "Att White's," he blew himself to one shilling, four pence. The price of a glass of "New England flip" in later Revolutionary days was nine pence. So perhaps he had one at Fisher's and then set them all up for the party at White's. There is no question that White's was a well-known stopping place for travelers on the "Great Road." This was before the days of stagecoaches. Folks rode horseback from Boston to New York on this first pike.

All the farmers and farmer boys of Tiot used the White Tavern as a club. Arriving travelers were their only excitement and source of news. Here they got the few messages and letters that came from the faraway world of Boston or Bristol. And, in the long, cold winter evening, it is easy to see them clustered around the blazing, spitting logs in the great fireplace of White's lower room—laughing, gossiping and drinking hard cider or, if they had the price, Jamaica rum.

One of the traditions about White's Tavern, which Grandma Chickering heard from her ancestors, who knew White's Tavern as well as you know the South Station, was the effect of the Salem witchcraft horror on our Tiot farmers.

During the years of 1692 and 1693, the reign of terror that was hanging or condemning hysterical girls and innocent, half-witted old women in Salem spread its evil influence onto superstitious and ignorant Tiot, as in every other little hamlet. Grandma Chickering said that at night, when the winds were howling down the Neponset Valley and the pine trees were moaning, when owls were hooting and dogs dismally barking at the moon, the farmers gathered nightly at White's Tavern and shivered with terror at each new tale that the passing travelers brought from Boston. With every creak of the old building, a new witch lurked in the chimney or attic. The rattle of the snow on the pane was the tapping of the dead hand of a Salem goodwife, whose body was swinging on the Boston Common gibbet.

The White Tavern legend that persisted the longest, however, is the story of two men and a boy who came to its door one day at sundown and asked to borrow a shovel. Mine Host White obliged, and they went away in the dusk—never to return.

Years after, a middle-aged man came to the tavern and asked White's son if he remembered the shovel incident. He said he did. The man explained he had been the boy of the party and that his companions were pirates who had landed from a pirate ship at Bristol with a bag of treasure. He himself had been a cabin boy. The three came up the post road and, after they had borrowed the shovel, had buried the gold near the White Tavern.

The stranger said he thought he could find the spot because if he couldn't, it was lost. The two pirates had been hanged in London. So he and White went out with another shovel. But things looked differently in the daylight, fifty years after that first visit.

Norwood's premiere treasure hunt ended in a fiasco. The ex–cabin boy went sadly away. And then the fun started. For years, the farmers in South Norwood dug for pirate gold. The neighborhood of White's Tavern looked like a prairie dog village.

According to Mr. John Guild, one man named George Somebody, in 1840, went at it scientifically. He got his inside information from a fortuneteller. Then he got permission to dig from Pleasant Street to the tavern. The info he got was not the McCoy. Later on, John Fiske, who owned the last pair of oxen in Norwood, worked out a theory that it might be under an immense oak on the School Farm. He darn near dug up the oak, but no bars or bullion.

So there is probably a big, bulging bag of pieces-of-eight somewhere around the ink mill. But when "the noble Duke of Googins and forty thousand men, dug up all the dirt and filled it in again" without striking anything except a billion gallons of H_2O, it looked as if the last great Henry White treasure hunt was over.

DEATH AT THE MUSTER: LONG FORGOTTEN TRAGEDY OF TYOT

Originally published on January 21, 1936

Have you ever played this popular parlor game called "Trick Questions —or What is Wrong with this Picture?" Someone tells a story that has an impossible fact in it. Then the players try to pick out the hickey in the yarn.

Well, if it had not been for Fred Larrabee in East Walpole, the writer would never have known that one can play this game up in the Old Cemetery in Norwood. He kindly gave me the tipoff on some family trouble I never

heard of among all the tragedies of our clan, which have been many. And out of it I will spin you a yarn.

Go up to the top of the hill in the Old Cemetery and there you will easily find a stone reading as follows:

In Memory of
CAPT. WILLIAM EVERETT
who was killed at the head of his Company on the 4th May, 1802, aged
45 years.
Stop traveler! don't heedless pass him by,
But drop the expressive tear, and heave a sigh.
Here lies a man whos heart was kind and free.
Whos soul oer'flowed with Godlike charity.

His wife's (Sarah, d. February 9, 1802) epitaph is quaint also:

Stop here, my friend, and shed a tear.
Think of the dust that slumbers here.
And when you read this fate of me,
Think on the glass that runs for thee.

Now your correspondent has read that gravestone of Captain William a dozen times, in a casual way, being as it is a sort of family antique. And it never entered my head to think there is something mighty queer about it. In fact, I merely pictured the gallant captain leading the charge up the redoubt, with the musket bullets whistling around him like anything. And the foe, of course, flying.

Well! What's the answer? Do you detect anything odd on the old slate tombstone?

Ah! Who said "*the date*"?

Yes. What war were we fighting in 1802? The answer is none.

Muster Day in Tyot

It was a beautiful morning that fourth of May 1802. All farmhouses of Old Tyot, scattered along Pleasant Street, which was the main stem and post road, on Dean and Guild Streets and up the hill toward Chapel Street had been buzzing since daylight. For this was Muster Day, one of the few great holidays of the year. Today, the Train Band would do its stuff on the muster field. They would wear their old uniforms, or perhaps new ones. Most of

Some of the final resting places of many eighteenth- and nineteenth-century Tiot residents are found in the Old Village Cemetery. *Photograph courtesy of the Norwood Historical Society.*

the old ones had gone through the Revolution. I doubt if there was much left of them except the accoutrements of buttons, belts, sword and flintlock musket, what Peter Everett inventoried in his will of March 19, 1748, as "his trooping harness." But regardless of uniform, the Train Band of our young republic's early militia would be out there to give its all for dear old Tyot in snappy marching and maneuvers.

There were three busy places that bright May morn. Or at least as busy as places were in those unhurried days. One was Abel Everett's Tavern, standing on the top of the little hill looking down on Tyot Village. This site is just where the Congregational church used to stand on Washington and Chapel Streets, or on the high ground at the right of the railroad underpass as you come up under it from South Norwood. Another hot spot was perhaps

Henry White's Tavern, where the ink mill now stands [in 1936], if it lasted as long as 1802. Near it was another oasis known as "the Arc." That may have been serving rum, too. And certainly the Red Tavern, near Guild's blacksmith shop on the Old Roebuck Post Road, on the hill just south of the present ink mill, was doing its part to get the local yokels and visitors to the muster as tight as was possible in those hard-drinking days. And a brand-new tavern, 'way up north on the Old County Road, run by Paul Ellis and Louis Rhodes, was getting the stagecoach trade at the bar. For the truth is, the principal reason they had Muster Day was to circumnavigate the mild disapproval of the deacons by holding one big annual drinking party. The oh-so-wet firemen's muster was only the legitimate son of the ah-so-wetter soldiers' muster. Here was one day when rum flips and hard cider could be drunk with impunity and genuine good fellowship.

The time set for the muster arrives. The villagers hurry to surround the muster field with an expectant throng. Dogs fight. Boys fight and scream, just as they do today up at the senior high between halves at a football game. Groups of soldiers come straggling, laughing and shouting from the various taverns.

Officers begin to shout commands—"Fall in!" "Guide up there! You such and such!" Probably they had a different set of terms then. But the meaning was the same. At last, the lines are formed. They are pretty straggly. Some of the heroes lurch about oddly. Lusty hiccoughs are heard, with subdued giggles from the well-illuminated farmer boys in the rear ranks.

Captain William Everett, "at the head of his company," is waiting to give the command that will start the maneuvers. *Bang!* A musket explodes in the hands of a man named Morse. Captain Everett claps his hand to his heart —and falls dead on the muster field, his life blood staining the green grass and dandelions at his feet.

Who this Morse was I do not know. Nor did Fred Larrabee. Probably it will never be known. But I do know that the killing of the captain, who had been left a widower only three months previously by the death of his wife, Sarah, was a terrible shock to the good people of Tyot. The man who had accidentally shot him was more or less sent to Coventry by the South Dedham people. This we do know. The rest of the tale is as follows.

This member of the Morse family owned a cider mill. Where it was, we do not know. Perhaps it was the old mill that stood at the southeast corner of Water and Washington Streets in East Walpole. However, it does not matter. He ground his apples in a press that was operated by a horse attached to the long pole, which squeezed the press down as the horse went around in a circle. One day, Mr. Morse was working the press alone. Something

happened. He fell down. Maybe he slipped on some rotten apples. Anyway, he went down so hard that he couldn't get up quickly enough to prevent the horse from trampling him to death.

And what did the members of the South Church of Dedham say?

"The vengeance of God has overtaken him!"

WILD STEER ESCAPES AND KEEPS TOWN IN TERROR FOR DAYS

Originally published on April 7, 1936, as "Silhouette of Old Tyot, No. 2"

Erastus Brown was master of the old South School of South Dedham. He had a butcher shop on Pleasant Street. One day, he was killing a steer. He had a thirty-foot rope around its horns in order to pull its head down and make it helpless before the butcher's club fell. But the steer had other ideas. It somehow broke away, rope and all. Away it went—tail in air and rope dragging. Down Railroad Avenue it charged, along the narrow, muddy little road and between the stone walls that then bordered that prosperous pike of today.

In its wake, no doubt, came the learned butcher and the market man, Mr. Brown, waving his arms and shouting. Naturally, the frightened animal went faster and soon charged across the S.B. Pullen lumberyard at South Dedham Depot and across the Smith Bros.' tannery property between the stinking tannery building and the equally obnoxious plant of the Fisher-Talbot oil company on Cemetery Street, now Central Street, and stopped, pretty well winded, near Joseph Day's barn.

Joe Day lived at that time in a double house that stood approximately where the municipal building now towers. Spencer Fuller, the foundry man, lived in the other half. The house had a high picket fence around it. Joe heard the shouting, for by now the Hook was out and running after and around the terrified steer. Seeing the trailing rope, Mr. Day did the natural thing that the high-cock alarm of the village would do—he picked up the rope and spoke to the steer sternly. Being in the leather business in Boston, he spoke steer language fluently.

Of course, the steer, living way over on Pleasant Street, had never heard of Joe Day. He did not know that Mr. Day owned about all the town that Captain Guild had not cabbaged. In short, he was not in any way awed by the words of the Honorable Joseph Day, representative of the people in the Great and General Court. So he put down his horns and charged Joe Day as hard as he could.

South Dedham's Joseph Day, steer wrangler, saved the villagers, literally "by the seat of his pants." *Courtesy of the Norwood Historical Society.*

To save his life, Joe jettisoned his dignity. Amid a mighty and delighted roar of laughter from the assembled villagers, he made a wild leap over the picket fence. He indeed saved his life, but not the seat of his pants. South Dedham at last saw the Honorable Joseph Day in the raw. Luckily, this happened near Day's barn. The door was open. Then it closed with a lusty bang!

The steer, robbed of its prey, pawed the ground by the picket fence, snorting ferociously—and trotted up Nahatan Street. But he went alone. The crowd cowered; it hung back, silently. Mr. Steer disappeared up the hill, ambling by the town pound on Nahatan Street, where he should have been, by rights. He may have given it a Bronx cheer as he passed. At last, he was reported by terrified runners as being loose in the woods that densely hedged in all of present Prospect Street.

There was a gossip grapevine in South Dedham in those days that was almost as good as the NE Tel. & Tel. Certainly it was cheaper. From white-faced mother or father to scared parent, the story of Joe Day's gigantic leap for life spread. And with every telling, the viciousness of the steer was magnified. Believe it or

not, it is a fact that my record reads: "The people did not leave their homes for three or four days. They stopped the schools." South Dedham was scared blue.

Now enters our hero, Captain Strout. In the Civil War, Captain Strout had learned to use a rifle. He was a deadly and expert shot. Shouldering his gun, he climbed Christian Hill on a still hunt for the elusive steer. It was reported here, then there! The captain patiently and skillfully followed each report. It took him two days of exciting hunting to locate the big animal in the Prospect Street woodland.

Finally, he ran it down. Creeping upon it like an Indian, he raised his rifle and fired one shot. The steer fell dead, a bullet through its forehead.

The next morning, the Everett School bell rang as usual. And Joe Day was seen quietly stealing across Washington Street to Oliver Morse's tailor shop, directly across the way from Day's home, with a little bundle in his hand.

TERROR AT THE TAVERN: TALE OF NORWOOD'S FIRST MAJOR CRIME

Originally published in August 1934

Carlos Marston, M.D.
Died Sept. 1, 1865
Aged 42 years

Susanna E. Tenney
Wife of C. Marston
Died Sept. 1, 1865
Aged 36 years

Cora T. Harris
Adopted Daughter of
C. and S.E. Marston
Died Sept. 1, 1865
Aged 10 years

This is the cast of characters in the tragedy I am about to relate, as it stands today on a cracked marble tombstone in the Old Cemetery in Norwood. You will find this stone leaning stark and alone under a great tree on the hill, near the Railroad Avenue entrance. The other graves seem to have drawn apart a bit from this one lonely plot, as if in mute horror of what the silent old stone tells those who know why it happened to be erected in that place and at that time. Truth to tell, there are few indeed in Norwood today to whom this stone means anything.

On this day, there was the distant sound of home-returning cows, lowing to be milked and fed, of roosters crowing and hens cackling in the tidy henhouses of Cork City. The six o'clock train from Dedham had rattled and bumped its way past Norwood Station on Railroad Avenue. On the long, comfortable piazza, which lazily stretched its length across the white front of the tavern, a few large, fat "drummers," marooned overnight in our village, smoked their after-supper cigars and told those hoary old stories that our present-day commercial ambassadors still retain in almost their original form. The odor of fried doughnuts and baked beans floated out of the dining room windows and made small boys hurry home to supper with watering mouths. And Mine Host, the jovial R.D. "Dick" Hartshorn was busy about his inn putting his horses to bed in his stable behind the tavern.

As the twilight lengthened into darkness, a gentleman with the air and clothing of a clergyman, his face troubled and solemn, entered the tavern door quietly and went up the narrow stairs to the second floor. It was the Reverend George Hill, pastor of the Universalist church. He went down the dark and stuffy upper hall, feebly lighted by a whale-oil lamp bracketed to the wall, and knocked at the door at the far, southern end of the building. It bore a modest card reading "Carlos Marston, M.D. Patients received during office hours or by appointment." A capable woman, who looked like a nurse, and was, opened the door and said, "Good evening, Mr. Hill. The doctor has been expecting you and will be glad to see you. Come in, please. He is with Mrs. Marston, but I'll tell him you are here."

On this quiet evening, these two old friends, Dr. Marston and Mr. Hill, were faced with a terrible responsibility and decision. For some time past, the mind of Mrs. Marston had been failing. At first it had been a slight irrationalness, but it had recently become downright insanity. An attendant had been hired to take care of and watch the poor, demented wife. Tonight, the doctor was at the crossroads. He must decide what to do with her because a country tavern and a doctor's office were no places for a crazy woman.

The doctor entered and gripped the parson's hand.

"How is she, Carlos?"

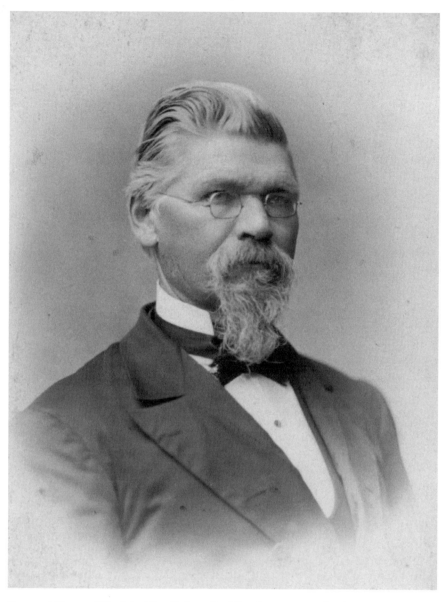

Reverend George Hill of the First Universalist Church was reported to be a good, sympathetic friend. *Photograph courtesy of the Norwood Historical Society.*

"Bad, George, very bad! We have had a terrible day! This cannot go on. What can I do?"

"Is she in her chamber?"

"Yes, right now. And apparently sleeping soundly. But she may be only shamming. Mad people are so sly! Wait a minute, I will look again."

He returned, "Yes, I think she is asleep all right. Sit down, George. Let's talk this out. Let us settle it tonight."

Picture the two men, sitting in that close, breathless hotel room in haircloth-covered chairs, with the dim, flickering light from a whale-oil lamp making their tired faces only paler. Far into the night they sat and talked quietly. The sweat stood out on the doctor's brow. His good friend frequently patted his knee in silent sympathy.

For, in those days, an insane asylum was not a great, spotlessly sterile, efficient and deeply humanized institution where sick minds were treated like sick bodies and frequently completely cured. No, it was a "Mad House." It was a grisly brick barracks, with bars on the windows at which crazed inmates rattled and howled and cursed an ignorant, unfeeling world. It was dirty and foul, with indescribable filth. And over its portals were invisible words that burned the very souls of those who saw their loved ones enter—"Abandon hope, all ye who enter here!" Hell, according to Dante, has a similar inscription.

Mrs. Marston was not asleep. As the men talked and argued, they did not notice the door had opened a fraction of an inch. Quietly! Quietly! Outside, in the dark hall, stood a figure in white. Hair streamed down over the nightgown; head was pressed to that slim crack of light; ears drank in every word of the fateful decision to place Mrs. Marston in an insane asylum the following day. The Mad House had won.

The figure faded away from the door like a wraith of fog and entered Mrs. Marston's bedroom. But that door did not shut completely, either. Within the room, the figure still kept vigil, with her ear to what might occur across the hallway.

About one o'clock, Reverend Hill bid a sad farewell to his friend and went down the stairs, after promising to return the next morning. Dr. Marston stepped down the hallway to the sleeping room of the nurse. He told her he was going to bed, as Mrs. Marston seemed to be quiet. But he suggested that she slip the inside bolt on her door—because his wife had been so troublesome during the day, he did not know but she might annoy the nurse during the night. Strange nursing technique they had in '65! Nevertheless, the nurse obeyed the doctor's orders and locked her door.

While the doctor was thus engaged, Mrs. Marston slid like a shadow from her room into his room, took his blue steel revolver from the bureau drawer

and hid herself in his closet. When he returned, he undressed and went to bed. No one will ever know why he did not step into his crazy wife's room to see if she was all right.

At about four o'clock, when everyone in the tavern was deep in sleep, Mrs. Marston came from the closet and shot the doctor through the head. Then she went to her adopted daughter Cora's room and shot her, also, through the head. Continuing on her fearful journey, she went swiftly to the door of the nurse's room, only to find it bolted fast against her rage. She returned to her own room, and placing the gun against her own head, pulled the trigger. The double murder and suicide was complete.

It was an early morning milkman, not the inmates of the tavern, who heard the shots. He ran into the taproom and finally got to Dick Hartshorn's room and awoke him. They ran upstairs to find the doctor's apartment in shambles—the acrid reek of the revolver smoke still in the air. The nurse was still sleeping peacefully. When she was dragged out of bed, she told such a conclusive and reasonable story that her complicity in the crime was never questioned. And it was from her story that they finally fixed upon the facts I have given above.

Of course, the constable was called at once. And he called on the town's only doctor, D.S. Fogg. There was nothing Dr. Fogg could do. The Marston family were all dead. He wrote out the death certificate as "murder and suicide." And what do you think he was given as his fee? The blue steel revolver.

MANSLAUGHTER ON BUTTERMILK PLAIN

Originally published in 1935

There was a strange and pathetic tragedy enacted one quiet June night in 1882 in the loneliness of Neponset Street, Norwood. An elderly and highly respected citizen was shot dead at one o'clock in the morning, June 19, by George Edmunds, who mistook the doctor for a burglar. The terrible mistake saddened Mr. Edmunds's life, caused our sleepy village to buzz with a fever of excitement and the story made the front page of the Monday evening edition of the *Boston Herald*, June 19, 1882. It is probably one of the first times that the Norwood dateline appeared on a Boston front page.

The two chief characters in this sad affair were well-known and well-liked citizens of Norwood. And its horror was heightened by several mysterious features that were never explained.

George W.S. Edmunds was a brave man. He was the son of H.W. Edmunds, who had, for many years, been the superintendent of the Dedham poor farm. George enlisted in Company D, Forty-third Regiment, on September 12, 1862, and was mustered out on July 30, 1865. He fought with the old Forty-third for the duration of the Civil War. With him were a large group of South Dedham men, who returned to Norwood and stood loyally behind their buddy when great trouble struck him so suddenly that peaceful June night.

Dr. Jarvis Gay, at the time of his death, was one of the oldest veterinary surgeons in the country. His age was seventy-eight years. He was born and grew up in the small, white cottage farmhouse belonging to his father, Colonel Jesse Gay. This stood, and still stands [in 1935] in a modern and renovated condition, at the very head of Cross Street, on the east side of Neponset Street. Shaded by beautiful old elms, it commands what the writer has always felt to be the most desirable view in all Norwood and is the homestead he would have preferred to own above all others. The history of Colonel Jesse Gay I have not been able to obtain, or to discover why he was called "Colonel."

At the time of the tragedy, Dr. Jarvis Gay was living with his wife and a son in the house that stood just south of the present electric light office on Market Street. The Brewster Press and a tavern now occupy the present building. But the old Jarvis Gay barn is still standing in the rear of this block. Dr. Gay was not only the oldest vet in town, but I think he was also the only one at that time. Like all men of his profession, he was called upon to make long trips all over this territory at any hour of the day or night. And it was well known that he was almost stone deaf. These two facts were directly responsible for his death.

Early in the evening of June 18, Dr. Gay got a call to attend a sick horse in Canton. The old gentleman went out to the barn still doing business behind the electric light station, hitched up his chaise and departed for Canton —never to return alive.

The rest of his movements remained topics of speculation in the village for many years. He did make his Canton call and started home. It seems evident that the doctor became lost at one o'clock in the morning on a road that must have been as familiar to him as his bedroom. Why he hitched his horse in front of his father's old home, which was now occupied and owned by George Edmunds, and approached the side door will never be explained. Perhaps he had had an accident in which his head had received a slight concussion. Probably the old homestead looked familiar in the darkness, and his poor mind thought it could find rescue at the well-known doorway. For

this was no friendly call at the Edmundses' house at one in the morning. The doctor, while perfectly well acquainted with both George Edmunds and his father, who, with his mother, were in the house at the time, was not in the habit of dropping in on them on his daily rounds. Something, never explained, caused him to go up the steps and rattle the door.

The noise awoke George Edmunds. He did the natural thing that farmers always do in such cases. He raised the second-story window and asked who was there. The Edmunds House then stood far from any neighbors, except the Joel Talbot House just across the street and the Cephas Hoar place far down the road toward the Fisher neighborhood. People took few chances in those days in lonely country places. They take fewer chances today.

The old man, being quite deaf, did not hear Edmunds's question or the noise of the opening window. In his hand, he carried an old-fashioned carriage lantern. In plain language, George Edmunds had a quick case of the jitters and thought he had a burglar to deal with. The unknown figure had not answered him and appeared to be trying to get in the house. Here is Mr. Edmunds's own statement as he made it later to Justice Ely at the inquest (you must remember, these are the words of an old soldier, to whom firearms were an everyday affair and to be treated with calm consideration):

> *I found there was no cap on the shotgun, and I went and got one and placed it on the nipple. I then went to a sitting from the window which opened on the driveway at the side of the house, and going up to the window, saw a light near the corner of the house and as it disappeared and then appeared again every few minutes, I took it to be a dark lantern. I though this meant the presence of burglars sure and I shoved the end of the gun thru the glass and pulled the trigger.*
>
> *Everything was still after the report of the gun, and, as my little boy said he heard someone running down the road towards Canton, I supposed I had frightened the burglar away, which was my intention when I fired. My father and mother have lived here alone for some time, and I only moved in with them two days ago, and I supposed it was an attack on them.*

But no one ran toward Canton. The full charge of shot had entered Dr. Gay's breast. He staggered down the steps and fell dead in the driveway. Medical Examiner Sturtevant of Hyde Park said he died almost instantly. There the body lay all night in the dark, while the Edmunds family went back to bed and to sleep. In the morning, they found the shattered body of the

elderly veterinary. After it was viewed by the medical examiner, Undertaker Sumner carried it to the grief-stricken family on Old Cemetery Street. The Gay family later conceded it was purely an accidental shooting, and the authorities all held Mr. Edmunds blameless of anything except an act that was probably too hasty.

INFLUENZA STRIKES NORWOOD

Originally published on October 6, 1936, as part of "5 Frontiers of Norwood, No. 5"

A pile of crude coffins, stacked like cordwood in Everett Hall of the Civic Association building, was the best advertisement the Civic ever had.

Unfortunately, it came too late. The message carried by that pitiful stack of caskets, in such a strange environment, was diluted by the anxiety and terror of the Great War then filling Norwood's citizens' minds. And hardly had those coffins been buried when George F. Willett, the mental and financial mainspring of the Civic Association crowd, ran into a morass of war work, ill health and great personal financial losses and difficulties that ham-strung his power as the Civic dictator. This eventually turned Norwood's civic activities and plans into other channels than those that had been surveyed by the original Willett group.

Yet the lesson of those coffins was not entirely lost. It jolted the idea into the minds of many influential people in Norwood that there was a good, healthy, selfish reason at the bottom of what they had been calling "this Willett moonshine and roses." They had a visible object lesson as to why the Civic Association had been organized for the Americanization of just three sections of town—South Norwood, Dublin and Cork City. It was to teach the newly arrived foreign peoples in these sections the lessons of love and respect for America, the existence of neighborliness among the Yanks, the lesson of cleanliness and sanitation, the value of education and the usefulness of healthy recreation and athletics. So it might be said that the coffins and horrors of the great influenza epidemic of 1918–19 were the beginning of the present Norwood Hospital, the high school, school athletics, the Callahan School, the district nurse, the milk fund, the community committee, the playgrounds, the more stringent building and inspection laws, the better and more friendly policing of South Norwood and the many improvements in that section. This list could be extended.

The Dark Side

Plague Hit Norwood Hard

Norwood was hard hit by the influenza epidemic which assumed alarming proportions late in September, 1918. On September 28 Town Manager Hammersley and Chief of Police Swift notified the Norwood Committee of Public Safety that the epidemic had become serious and a meeting of that body was called...The Civic Association building was equipped as an emergency hospital. Dr. Lewis H. Plimpton volunteered his services and was appointed head physician of the emergency hospital.
 —*C.E. Smith, "Historical Sketch of Norwood,"* Messenger, *December 31, 1920*

The State Department of Public Health supplied two physicians. Members of Company H, Thirteenth Regiment, Massachusetts State Guard, were ordered to report at the hospital as orderlies. Two nurses were supplied by the Massachusetts Emergency Health Department.

Through most of that dark October, the schools and theatres were closed and all public meetings banned.

Desperately serious cases of influenza poured into the Civic Association Hospital. They came from South Norwood and surrounding towns. But it was soon found that they were hiding their dead in South Norwood. Bodies were discovered under beds and in closets. People who, for generations, had been taught to look only to authority for blows and curses, could not imagine that the police and others who came to comb the three-deckers were there to help and protect them from the filthy sanitary conditions that neglect had allowed to develop. They were afraid to tell them their loved ones passed away under the black hand of the plague, which struck and killed in twenty-four hours.

Gradually, however, the word spread that the Civic was a better place to be sick in, or to die in, than an overcrowded tenement. The dead ceased to be secreted, and people came, or had their sick brought, to the hospital voluntarily. By the end of October 1918, the epidemic was under control and cases transferred to the small Norwood Hospital. The crowd of Boy and Girl Scouts, teachers, guardsmen, professional social workers and all others who had fought the plague as men fight a forest fire rested from their frantic labors. The Winslow School was opened for the children who had been left destitute by the death or sickness of their parents. Here they slept and ate.

But the end had not yet come. During December 1918, the epidemic again flared up. Again, ghastly scenes were enacted in the Civic hospital. Again naked men and women, wild and unmanageable in the delirium of

the disease, ran amuck in the old building until subdued. Again they began to die like rats, and again the coffins were stacked by the wall. Again the schools and all public meetings were closed. The epidemic was not under control until the middle of January 1919.

"The number of influenza cases in town during September and October 1918 was reported at 1623," writes C.E. Smith. "The deaths due to the epidemic during this period numbered 101, of which 91 were residents of Norwood and 10 residents of other places who died in Norwood after being brought here for treatment."

It was this epidemic that caused many thoughtful people in Norwood to see South Norwood with new eyes. They realized for the first time that it could no longer be ignored as a real estate speculator's paradise and the dumping ground of the peasantry of Europe. Whether they liked it or not, they saw it as a definite part of the older town, with latent powers to make or mar the latter. Through death and suffering, North Norwood had become acquainted with South Norwood.